THE MAN AND HIS PAINTINGS

REMBRANDT

REMBRANDT

EXCALIBUR BOOKS

NEW YORK

Copyright © 1978, Henri Scrépel, Paris

First published in USA 1980
by Excalibur Books
Distributed by Bookthrift, Inc
New York, New York

ISBN 0-89673-063-8
LC 80-80715

Printed by Librex, Milan, Italy
Bound by Webb Son & Co. Ltd, London, England

I

Introduction to Rembrandt

Claude Esteban
Jean Rudel

Simon Monneret

Translation by Dr. Lucia Wildt

Study of a face

Claude Esteban

I often wonder what we would know of all those artists, painters and engravers whose portraits intrigue us, apart from what those portraits themselves reveal, what they seem to betray, almost unknowingly, of what lies beneath the surface. Of course, even in the case of the most secretive of artists, the signs are there to allow us to follow their progress, to discover some internal anxiety; and these signs could be just a matter of a few fruits on a table, a patch of clear sky, a touch of shading on the crimson dress of an *infanta*. It is the china painted by Chardin, the rocky architectural structures of Poussin, Courbet, Cézanne, that allow us to guess at the nature of their environment and their hopes, thus adding to the information provided by their few disclosures or by those rare self-portraits by which we hope to be able to identify them.

The painters themselves never had any doubts about this. They kept going back to the original motifs of their search, to the nearly unalterable scenes which had fascinated them from the beginning, as though they could discover in them not only the mystery of the world but also something about themselves. Why, then, this need to explore one's own face? The apple should be enough, the pewter jug; and if the painter sometimes turns away from them towards a mirror what he will be able to grasp of himself will be no different from that reality which

obsesses him: clear volumes, the interplay of visible shapes, eminently tangible. Cézanne himself declared, at the beginning of this century, that one should paint a face as one would a fruit-dish. Yet it is faces which survive. The similarity of approach, however attractive it may seem, does not say anything —far from it—about the specific features of the human face; nor about the technique of portraiture as we can come to understand it through the history of Western painting. When a portrait eventually emerges, it almost always seems as though a human face—above all in the art of Cézanne—presents only a simple superficial arrangement of features in order to hide itself in the distance, within an impenetrable enigma against which our eye, misled by the artist's eye, stumbles in exasperation. Let us just look at some of the self-portraits by Velasquez or van Gogh, at some of the effigies of Giacometti or Francis Bacon that literally stare down at us; it will then become clear, I think, that, far from helping us gain a firmer control on the person they depict, the process which led European artists to try to capture their own features has maintained and even stressed the distance between the painter and the image of himself he tried to fix. No doubt this is why the artists best attuned to the essence and the flavor of the immediate present considered very carefully this kind of exploration and preferred what has long been regarded as a more

stable subject, the objective appearance of things, to the hazardous pursuit of their own identity.

And this is what we find disconcerting, when we look at the development of Rembrandt. His portraits constitute almost three quarters of his paintings; of these, a great many are self-portraits, whether signed or attributed, and they play an essential role in the development of his art. Even if we discard the dubious attributions of old catalogs and stick to the canvasses properly authenticated, neither the proportion nor the importance of the self-portraits will be appreciably altered. Gerson counted over forty self-portraits out of a total of 420 pictures he attributed to Rembrandt. To these one should add the numerous engravings, drawings, and sketches, in which Rembrandt examined his own face. Such careful self-depiction, from adolescence till death, poses not only a purely historical problem. This attraction, even obsession, pursued over more than forty years, must have arisen from a kind of preoccupation quite different from compulsion or sheer pleasure. In a Holland so attached to its privileges, so proud of its material and spiritual fortune, who would have expected the painters of Amsterdam or Leyden to portray anything else but majesty and magnificence? Merchants, shipowners, functionaries of the Church or the Law, they all wanted portraits confirming their status and their rights,

the justice and self-possession they stood for. What prince except a foreigner—and it happened once in the whole of Rembrandt's career—would have thought of buying a canvas on which that sullen, once famous and soon forgotten man tried to capture his own image? And history tells us that the Grand-Duke of Tuscany did not carry out his intention. . . . One should not forget that Rembrandt, like his master Lastman, began as an historical painter. And this and nothing more is what his first patrons expected of him: that he should trap the memory of ambitious glory, or fix in their deportment and gestures the drapers and doctors, architects and bankers, the people who ruled the world.

However, Rembrandt never bowed to the imperatives and the demands of a society which, as he was soon to learn, would be of no help to him in his enterprise. Some of the portraits of famous men, the *Anatomy lesson*, the *Night watch*, seem to reflect the vision the Dutch cherished of their own status; but they also witness another, more obscure ambition, the key to which lies in the remarkable series of self-portraits. Whether he paints a period scene, or depicts a Biblical episode, or keeps coming back to his own face, Rembrandt is trying to tell a more essential history, intrinsic to the individual and bound up with his destiny: the history, so far unsuspected, of the person. Of course, in the North, and more clearly in the heart of that Italy which never ceased to fascinate Rembrandt, many artists had combined mythical or religious scenes with portraits of donors and monarchs. But generally they had confused a person with his function, creating a kind of allegorical register in which a man's physical peculiarities were dissolved and idealized, turned into symbols of an unbreakable order, visible proof of a hierarchy both human and celestial. Let us look at the major portraits of the Quattrocento: the status of the protagonist takes over his personality, dimming and smothering it under the emblems of honor and the ceremonies of appearances. Even Raphael and Michelangelo remained faithful to the vision and intellectual

version of Piero, although they gave their portraits the authority of a Prince or the grandeur of God.

Rembrandt, a few years later, did not underestimate these lessons, nor the harmony they reflect, nor the intellectual self-confidence which he felt he was lacking. But when he tried to paint a face he turned to another Italian painter; he directed his inventiveness towards a completely new experience, however misinterpreted and misrepresented in the work of some followers. He certainly never saw the works of Caravaggio, having never launched on the Italian journey. It is through the interpretation of the Dutch Caravaggists that Rembrandt met the master of *The vocation of St. Matthew*; without this meeting, his genius as a portrait painter would not have realized itself so soon. And yet, what was there in a Honthorst or a Terbruggen of that marvelous art of light, that creeping obscurity, that dramatization of unhappiness and violence so splendidly created by Caravaggio? Their futile rhetoric, their exaggerated taste for genre scenes, for the picturesque or the truculent, were only distant echoes of the poignant *terribilità* of the Italian artist. Rembrandt, from the age of twenty, saw through these pale replicas: he saw the strength and the spiritual expressiveness of which there are ample proofs in this art, unfortunately mistaken for poor naturalism. All his first self-portraits—particularly the

canvas in Kassel, dated 1626, and the series of portraits of the years 1626–30 crowned by the dazzling figure in the Mauritshuis representing the artist wearing armor—all these effigies of the young Rembrandt well illustrate the tremendous attempt at self-elucidation undertaken by the artist, inspired by that man, who, in Rome, had boasted to have no other master than nature.

Under the appearances of surprise or serenity, a grin or a smile, Rembrandt approached the task of painting himself, not in the anecdotal manner of his predecessors, but faithfully depicting his own emotions and moods. This was an inherently psychological task, endangered by a certain narcissistic introspection, the perils of which were denounced by Pascal some thirty years later. But no matter. It would be useless to judge the youthful self-portraits in the light of the later masterpieces which obviously surpass them in depth and sharpness.

What is of interest here is the care Rembrandt put into freeing the

study of his own face, both in plastic as well as moral terms, from the canons of sentimental academicism and convention, from the stereotyped humors and effects which constitute the 'natural' expression of a face in the work of so many Caravaggists, even Frans Hals. The deep attraction the young Rembrandt felt for the peculiarities of an attitude—what in the XVII century was called 'magnificence'—for the strangeness of a pose and even for uncomeliness, barely avoids the grotesque, which was soon to become popular with caricaturists and which was never anything else but an inferior brand of adverse idealization. Rembrandt does not try to depict on his own face or on that of his relatives, superficial expressions, however reassuring. He tries to invest man with his deep capacity for expression, to endow him with his emotional and psychic qualities. But he can only achieve this by lingering on appearances, by depicting the features which are supposed to express emotions. In order to come close to himself, he must, paradoxically, explore first of all the extremes of sensual manifestations, miming joy and sorrow, gravity and bonhomie, as if human truth could be found also in the successive and contradictory, sometimes incoherent, masks adopted by his face.

However, we can soon watch him—particularly in the 1638 self-portrait recently exhibited in Liverpool—as he slowly abandons those 'humorous faces', those studies in

moral idiosyncrasies which Hals always cultivated. Expressiveness as an end in itself is perhaps only the result of a too impetuous approach to a face and the person it represents. It obeys a kind of mathematics of the passions which one finds in the great compositions of Caravaggio. To stress the external superficiality of illumination, whether optical or psychological, is to accentuate the contrast between darkness and light and to preclude the use of an overruling light under which man can be seen in the entirety of his being. But is perception anything more than an amalgam of figments? It is now that Rembrandt begins to paint himself no longer as the young ironical or presumptuous artist he might have been, but in oriental costumes, in warlike ornaments which allow him to simulate the characters he has never been and of whom he dreams, within the space of a canvas, to become. Huizinga interpreted this attraction for ornament and disguise in a way which substantiates our first impression: 'All his life Rembrandt pursued his dream to represent another world, and a way of life other than the one in which his day-to-day existence drifted by, the life of middle-class society in the Dutch republic.' However satisfactory from the point of view of the historian, this purely circumstantial explanation cannot entirely convince us. It only states certain choices, it does not explain them. Why the oriental costumes rather than the Roman ones which were

dear to other painters imbued with classicism and Latin literature? Not all is explained by the vicinity of the ghetto or by the great market for the world's goods that Amsterdam had become. And above all Huizinga's comment does not explain the pensive, almost melancholic, quality of those works in which the painter likes to represent himself in clothes more appropriate to pomp than meditation.

When we look at these paintings, executed mainly in the years around 1640 and almost all before Saskia's death, we have to recognize that the interpretation suggested by the Dutch historian is insufficient, if not wrong; it only considers those elements of Rembrandt's internal development which sever him from a social and historical context, not those which bring him nearer a region more metaphorical than real, in fact an intellectual place in which the artist imagines he will settle. By turning to the Orient, Rembrandt expresses a desire quite different from the one simply to get away from the extremely prosaic society which surrounds him. This fantastic pretension does not indicate a dissimulation, a flight, even less an endearing spiritual *divertimento*. When he donned those turbans, those Persian tunics, those glittering jewels, Rembrandt did not mean to bow to the rituals of some Turkish fashion which enchanted the rest of Europe. The *Portrait of a man in Oriental costume* is not

Mr Jourdain in disguise; on the contrary, this painting, and others like it (*The feast of Belshazar, The departure of the Shunamite wife, The reconciliation of David and Absalom*), reinvest the Orient with the stature which it held for the first Christians and which it will find again, two centuries later, in the thoughts of some poets. To the solitary artist of Amsterdam, the Orient is the incarnation of both the splendor and the restlessness peculiar to the human condition: a dream of the soul, as it will become for Nerval, the land of temporal magnificence, and above all the country where the Word of Truth was born. It is towards this land that the Dutchman, muffled in velvets and ringed by collars, turns his dreamy eyes; it is there that he will place his scenes of pardon, love and gratitude. Besides, on the question of using costume which has sometimes been held against Rembrandt, one can add that the 'disguise', as understood and used by the painter, invests each figure with a value which goes beyond their personality, and which somehow opens a dialogue between them and the great souls of the past. The scene which Rembrandt plays in someone else's guise, under the appearance of historical or fabulous narrative, is not concerned with the real world whatever the search for the 'cosmic illusion'; this is the game of mirrors that the Baroque will appreciate above all. The deployment of world history does not obliterate the individuality of the person who is

staring at us; rather, it confers a majestic dimension to the natural theater of passions.

This majesty, this dreamy solemnity with which Rembrandt will try to the end of his days to invest himself, he thought he recognized since his youth on the faces of old people. He questioned their declining figures at the same time that his other portraits—whether of himself or of his rich clients—were describing a vigor and almost a 'greenness' of life. Was it a presentiment of what one day his own face would be like? Another anxiety, not entirely justified by affection, appears in the attention he pays to the features of his father or his mother. Among the lines, within that framework of flesh which wrinkles and collapses, there lies a strange mystery that youth knows nothing about but which the more vigilant spirit detects and is haunted by. The face of a man is not only a place of freely realized moral or psychological qualities; it is also the vessel of an inalienable continuity which flows during a physical lifetime. Each desire, each thwarted hope has left its signature on this increasingly friable clay. Rembrandt never ceases to explore this secret history, in search not of some image of vanity but of a dark promise of permanence. These old people who, unbeknown to Rembrandt, appeal to the old man he will become, are not effigies of bitterness, pride or disillusionment; they forecast, in 22

their own shy way, a world and a land of peace beyond the torments of the flesh and harrowing vicissitudes of the soul.

It is hardly necessary to refer to the last self-portraits to understand the development of the painter from the plastic expression of passions to the intimate exploration of a face. What Rembrandt cannot discover about himself in the mirror of his thirty years, he discovers in those who preceded him in age and in that experience, more spiritual than temporal, which, once consummated, is called a destiny. This meant, in a man born in an age of certainties, the violation of commonly accepted laws of psychology and anthropology which still ruled over artists, thinkers, poets: youth should be equated with arrogance and impetuosity, age with pomp and decrepitude. In the forty years in which he painted portraits, from the first one of his mother to the last one of Titus, Rembrandt continued to unveil a vision of man in which the 'ages' melt and almost disappear

23

into one another; and where the light in the eyes of an old man is fresh and new, while the face of a child is shadowed by an undefined future history.

With this in mind, we may consider that admirable canvas depicting a Biblical character, *King Ozias struck by leprosy* as it is nowadays called, painted when Rembrandt was not yet thirty. Let us compare it with those faces he continued to explore, his own and his son's, until their deaths within a few months of each other. In both cases one can almost see the same innermost light; on the proud face of the old king are the signs of extreme tiredness, of the illness which destroys the body but wrenches the awakened soul from the delusions of power. At the threshold of death the once powerful old man appears as vulnerable as a child, divested of all his illusory riches and freed from what he used to be. The child receives him and shares with him the same final solution. In his own maturity Rembrandt pauses to observe the various faces of childhood; like the young girl, probably a house maid, leaning on a window sill or holding a broom, her features, similar to those of young Titus, steeped in a kind of trembling emotion. Rembrandt discovers in the faces of these creatures still untroubled by the world that authenticity of the individual which eluded him in the masks of merchants and pompous noblemen. But the innocence does not exclude a

certain gravity, a dreamy seriousness which goes beyond the knowledge the little maid could have had of herself. In a child, Velasquez found candor, Goya fragility and obscure terror, Rembrandt the inscrutable future and the complex past. The portrait of young Titus at his desk is no different from that of king Ozias or from the last self-portrait in The Hague. They all tell the same story of loneliness, of a silent will venturing into the maze of its own history—a history which we all, young and old, know we have to face. As Claudel wrote: 'All these portraits have known what night is like. It is not a matter of looking at the present, it is an invitation to remember.'

Caravaggio had discovered the dereliction of man lost in a universe from which the name of God had vanished. Rembrandt extracts from the ruins an immortal world. There has been much argument about his 'christianity', and it is beyond the scope of this study to enter into a discussion which cannot clearly explain his spiritual development. Let us instead try to grasp the meaning of what one might call his 'conversion' to Christ's message independently of all doctrines and churches; and let us do this in the light of his last self-portraits, particularly that most enigmatic of all, the fine *Self-portrait as the apostle Paul*. He never stopped painting his religious scenes and there are no grounds for believing he painted them only on commission. In

the few letters we have, he always underlines not only his 'zeal' but above all the 'devotion' which enabled him to complete the great compositions on the theme of the Passion commissioned by the Prince of Holland. Canvasses like *The erection of the cross* in Munich or *The deposition from the cross* in Leningrad, which today appeal to us less than others, testify to this 'devotion'. In the grandiose scenography of the sacred drama, in which pity and terror are the prime movers of religious emotion, only a few signs show a less ostentatious fervor: the anguished looks of the man who lifts the cross (and in whom Rembrandt has revealingly mirrored himself) or the face of the knight almost detached from the crime which is taking place and yet an unwilling witness of internal anguish.

These canvasses bowed to the requirements of an ostentatious pathos in which Rubens had excelled. One finds no trace of exacerbated devotion in the *Portrait of the apostle Paul* executed the same year in which the first version of the *Christ at Emmaus* was painted. Once again, we are caught by a certain image, a man engrossed in meditation with whom Rembrandt will gradually identify himself to the point of depicting him with his own features, thirty years later, in the *Self-portrait as the apostle Paul*. One feels that this identification of the old painter with the apostle has not been questioned enough—or rather that

nothing more has been seen in it than one of the masks used by the painter, throughout his life, to depict himself. And yet it entails a lot more than just a disguise. This unusual alliance between the sacred and the profane shows, in my view, the emotions felt by the painter: the spiritual world is not a notion of the heart, rendered more obvious by dogma; it is a summons in the night, a calling which any man can follow. All one needs is an act of faith. Man's destiny is to join his own image which is not the perfect and unalterable one suggested by established religion, rather a more humble one, burdened by loneliness. The apostles as painted by Rembrandt cannot be identified by their attributes any more than men can by the instruments of their work or of their power. We can only risk a distinction on the basis of the depth of their expression and the illuminating charity of their beings. In fact, they are apostles only in so far as they believe and pray more than us. But according to Rembrandt any man can become an apostle, even the wretched painter who does not hesitate to say so on a canvas.

It is on the path of loneliness and doubt that the pilgrims of Emmaus meet with a comforting 'presence'; and in recognizing their Lord they finally know themselves. Christ is nothing else than the most defenceless of his disciples; he assumes our own face the moment we accept we are only the sons of man.

27

Rembrandt reaffirms the eschatological dimension of man but does not divest it of a certain carnal entity. Let us have a look, once more, at the last self-portraits. It is always the man who comes to the surface, the man inseparable from his destiny as painter, with that look which never ceases to explore the invisible, without haste, almost without emotion. Yet the shadow is catching up and the smile on the Cologne canvas is no longer the grin of the young hero of yesterday: it is rather the resignation of one who no longer doubts that he will enter into darkness and share the night with the unnamed. An old man unconquered by death, a mask suddenly struck by ascending light.

Rembrandt:
change and transition

Jean Rudel

Should one look for truth in myths, or rather see them as nourishing one of the basic needs of the human soul? Is Rembrandt Van Rijn not indeed that Rembrandt *of the Rhein*, born where that immense river pours its waters, rich in so many legends, into the vastness of the sea? Lands of transition, these Low Countries, and also of mists, the filter of powdery and diffuse lighting; an immense chiaroscuro often covering all these lands risen from the water. Technique and dream. . . .

Rembrandt embodies all these elements, giving his environment a sense of poetry; not only the sense of a living world, but also that of a biblical dream, of an indefinable nostalgia for God—the image of a 'divine environment' perceived to the full depth of its materialization and its silence. Visionary world of a mysterious transition: all of Rembrandt's art seems to have been born of this strange sense magnified and enhanced by the dialectic of light and shade, and comes to express a certain Dutch truth as well as its own. That is why, in order to understand Rembrandt, one must accept the risk of a spiritual adventure and of the material projection it demands. All Rembrandt's art requires this exploration, this projection of one's sight towards the twilight universe which defines it and the journey through its evanescent shadows, its strange, tapestry-like backgrounds on the verge of something uncertain and evasive.

Most of the canvasses inspired by chiaroscuro appear to us like colored abstractions from which one can deduce shapes. Let us look at such compositions as *The conspiracy of Julius Civilis* of 1661 (p. 118), *Jupiter and Mercury visiting Philemon and Baucis* of 1658 (p. 108) or the *River landscape with ruins* of 1650 (p. 114), respectively in Stockholm, Washington and Kassel: they all show, irrespective of their subject, the same hallucinating transmutation of light. Shapes decompose and recompose themselves according to a texture which tells of the strange adventure of a universe in which color becomes light either emerging from or drowning in the magic shadow of the chiaroscuro.

All this had already been disclosed since the years 1627–30; from the *Presentation in the Temple* (1627) in Hamburg, or the *Scholar in a lofty room* (1631: p. 66) in Stockholm, to the *Self-portrait* in Cologne (1665) or the old Simeon (1669; p. 130) again in Stockholm. Rembrandt's art is all here, in this transparency even in the darkest shades, in this substantiality of a light captured in, and beaming from, a mystical diamond; this, together with the plastic themes which animate, justify and constitute the reality of a myth born out of time, seems like an endless search for the other world. There are two essential themes: the light diffused by the open window (e.g. *Tobit and his wife*, 1629–30, in the National Gallery, London, painted again in

32

1659; *The philosophers*, 1631, Louvre, and The Hague) and a strange form of shadow, a 'transferred shadow'. These frequently repeated motifs, like *leit-motifs* constantly present, are symbols of a duality between hope and anxiety, refuge and nostalgia, which constitutes the structure of this art, both in terms of meaning and of plastic composition. And above all, between these two polarities, the face and the landscape, we find the improbable wrapping-up of all the effects of a chiaroscuro into which light spreads and streams; a light which seems to emanate now from a far away land, now from shape itself, as in that astonishing version of the *Christ at Emmaus* (1648) which is in the Louvre. All of Rembrandt's art is in this complexity of visions stemming from light and shade, constantly, yet in each case differently, evoked as if this antinomic association were at the core of our life and therefore of our destiny. That is why all of Rembrandt is in each Rembrandt, whether we look at Biblical scenes, landscapes or any of his dozens of portraits. He shows us a world of apparitions and disappearances into a different world suggested by the subject. Each constituent of this art is at the same time the sign of a thought which only exists through its language of imagery—a *plastic thought* which rejoins here the original significance of the religious image as it transforms it into an indispensable medium both to emotions and thought. Here

33

lies the fundamental point about all the pensive characters, all these philosophers, all the figures who appear to be silently meditating. Let us consider, for example, that philosopher in Stockholm: what a strange, magical and grandiose poem of light, notwithstanding the small size of the painting (60×48 cm). Everything moves, flooded with light down to the minutest detail; all is transition towards that interior universe, which is stressed by the semi-circular vault and which Rembrandt will often evoke again. Look at the surge of light around the head of the philosopher who becomes the source of its diffusion; everything here disappears into light, is consumed by it, while at the same time becoming a particle of transfigured matter thanks to the incredible softness of those beams emanating from the wide opening of the window, which is in turn one of the major features of the painting. We are faced here with an incredible alchemical manipulation of golden powder, similar to Danae's rain, but much more lively thanks to the contrasting bluish greys which one notices beneath the pulverization of light and in the background. And there, like a mysterious passage leading to an even greater secret, is a closed door, almost diaphanous in the luminosity of the background; a total transfiguration which penetrates and dissolves all shapes, and, well before Monet's *Cathedrals*, suggests an enchanted world.

All here is serenity, without the heaviness we find in the other philosopher, the one in the Louvre, seated near a winding staircase which looks as if it leads to another world and symbolizes the ineluctable movement of life. There are two sources of light here, either side of an undefined chiaroscuro which merges with the pool of shadow at the top of the staircase; one is the real outdoor light, the other the artificial light of the hearth, the latter a reflection of the former, a platonic symbol. This is a canvas laden with suggestion, with nostalgic nuances, with such warm colors that matter itself crackles strangely and seems to be born of a dying Fall; and also with a sense of the transient and passing, as we find in so many other works, like the *Jeremiah* of the Rijksmuseum executed around 1660. One should linger to examine him, this meditating philosopher, a character dear to Rembrandt as a sort of image of himself. Here he introduces us to an intimate universe symbolized by the vast shadows surrounding the prophet; shadows which represent a kind of fantastic splitting, while at the same time constituting, with the prophet, the main structure of the canvas. Form emerges from shadow and is detailed by a progression of light which leads to the almost tangible head, the brutal simplicity of a profile underlined by a beard so flamboyant that echoes of it are later found in van Gogh. There is mystery in the luminous transition

from the whitish and golden substance of the hair to the more sombre hues of the background. All comes and goes, emerges and disappears, between light and that fragment of shadow, surrounded by chiaroscuro, which represents the prophet's eye. A strange background, too, an environment brought to life by a pictorial substance which can be compared with a whole universe of anguish, loneliness and transition, as suggested by the meditation of the prophet. A true portrait of a mood, it explains the admiration the Romantics felt for Rembrandt, particularly Delacroix.

The thick, atmospheric colors fill the background with a magic shadow born out of far-off fires, a shadow which becomes drama, the sign of divine curse and the passage of time. A mysterious shadow is also contrasted with the group of sacred objects which hide the Bible; the objects are receptacles of light, reflecting that which comes out of the fire and from Jeremiah's head. The light thus forms a triangular movement on a diagonal, a sort of refuge from the bloody reality of Jerusalem: a magic of light and shadow, never devoid of questions and dreams about destiny—this 'other thing' which appears everywhere in Rembrandt.

This is what one feels when faced with that masterpiece in the Louvre, the *Christ at Emmaus*, painted in 1648

(p. 88). The incredible look on the face of Christ radiates over the painting—and it can withstand any enlargement, made as it is of a marvelous substance from which the hallucinating eyes emerge, eyes which look like windows on the other world. We find here all of Rembrandt's favorite themes, like the contrast between light and shadow created by the figure on the left; or the dramatic strength of 'transferred' shadow, felt like a symbolical presence and integral part of the whole. And again, the theme of the arch coupled with the indefinable treatment of the shadow in the apse; and above all the diffusion of a stunning light, which emerges both from the face of Christ and from the objects it transfigures. The overall effect is one of radiation, of movement, of transition and passage, always apparent in Rembrandt and expressed in two ways often used together. One relies on what might be called an 'external' composition according to a diagonal construction, indirectly and partly inherited from Italian Mannerism; the other arises from the intimate formulation of a chiaroscuro which is the basis of the existence and meaning of the painting. Rembrandt had probably learnt the former from his first masters, like Van Swanensburg, who had been to Italy, and undoubtedly also from Flemish Mannerism and engraved copies of Italian art. Such a construction appears very clearly in works such as *Christ at Emmaus* in the Jacquemart-Andrè Museum; or is

37

sometimes partly hidden by the interplay of shadows, as in *St. John the Baptist preaching* in Berlin-Dahlem or *The Holy Family* in the Louvre. But Rembrandt often substituted it with an asymmetrical arrangement, as used in the majority of his drawings, according to a ternary relationship which one also finds in works such as *The conspiracy of Julius Civilis*, *The feast of Esther*, (in Moscow, painted in 1660) and numerous landscapes.

But for Rembrandt to 'compose' is not to 'construct' in the Italian style, rather it is to create an organic movement of shapes which either emerge from, or disappear into, the shadows. One can see this quite clearly in that famous *Night watch* of 1642, the same year as Saskia's death. The canvas shows a dire conflict between the necessity to compose an official scene and that to express himself. Perhaps this is the reason why, once more, in the history of art a false title has been superimposed with such exactitude: the work is also, in the long term, a personal manifesto. The heraldic standard of the Company is more than a mere reference to the subject: it links the order of the composition with the informal element of shadow, from which so many patches of light appear like momentary visions of a transitory world, instances of light which rests and becomes form before setting off again towards shadow and oblivion. Such glitter in a dreamy vision in which the more precise descriptive details of

the costumes become fragments of light! And as for Captain Franz Banning Cocq, he seems to exist beyond reality: a pictorial and psychological answer to the shadow of the arcade which, as we know, is more than 20 centimeters too short in proportion to the original one.

Only shadow rules over the dance of light. Structure and movement under all circumstances suggest and dictate form. It is this, the theme of the huge shadow, which resembles the unreal architecture of a transitory environment, just as in *The presentation in the Temple* (1631) in the Mauritshuis, or in *The woman caught in adultery* (1644), in London, where this shadow becomes a palace of night.

It is more often the case of the effect created by a transparent shade, by chiaroscuro, the means of transition and passage *par excellence,* around which the whole of Rembrandt's art revolves. Fromentin, in his *Maîtres d'autrefois* (1876) has written unforgettable words on this subject: chiaroscuro is for Rembrandt 'the inborn and necessary form for his impressions and ideas'. 'A highly mysterious form, shrouded, elliptical, rich in implications and surprises . . . more than anything else the form of intimate feelings and ideas . . . it is part of sentiments, emotions, uncertainties, of the undefinable and the infinite, of dreams and ideals.' And it is for Rembrandt the essential form of

a language otherwise untranslatable, as it had already been for Leonardo da Vinci.

Undoubtedly, this chiaroscuro is a visual form of Dutch life, as we have already said, since it brings with it a light diffused along the canals and inside the houses. Many generations of painters had used it before Rembrandt, but they had *described* it as a natural element; many had also toyed with shadow and night, Terbruggen, for instance, Honthorst, Claesz, or Rembrandt's own master Lastman, to whom he was deeply indebted. Chronologically, Rembrandt was their successor; except that for them shadow and chiaroscuro were just natural phenomena, which they had simply learned to manipulate deftly. Rembrandt's interpretation is quite different. The chiaroscuro is certainly a phenomenon of his visual environment, but it has also become the expression of his own interior world; it only exists because of that particular way of 'drowning truth with imagination' by steeping light in a bath of shadow, out of which it is later extracted and made to appear more distant, more radiant, but also, all of a sudden, more concrete. Hence his retouches, so solid and thick as if made of petrified light reincarnated in the middle of a constant dialogue between light and shadow. It is this, a mutual rebirth already suggested by the colors, which we find again and again—expressed in different ways according to the

medium, but which even the slightest opposition always relates to the dialogue, the indefinable transition already so dear to Leonardo. Less dialectics than constant relation between two aspects of the same movement within life and within ourselves.

One can easily detect this, even in the most definite contrasts, like those we find in the right arm of the so-called *Danae* of Leningrad, painted in 1636. The highlights and shadows on opposite sides of her face cause the form literally to vacillate towards the deep shadow of the curtain, similar to a huge dramatic void integrated, however, with the general rhythm of the composition. A kind of transition by contrast, merging, however, with the substantial lightness of the shadow; a lightness one finds in other works, such as the admirable *Woman with a fan* (Widener Collection, Washington; *c.* 1667). Here, the surge of the volume from the shadow, the endless sweep of colored surfaces, the detached expression of the face, carry us again beyond the actual shapes. Again, a constant feeling of transition, suggested by all those eyes which talk to us from his various portraits. How many intimate glances from eyes which are nothing but a touch of shadow, a *hole* of shadow, the symbol of a journey toward a different world.

Beyond the image, then; thanks also to its texture, since the very technique used by Rembrandt equally— I was going to say necessarily—renders this feeling of transition; is it not *his* technique which is, in each of his paintings, the expression of a fundamental yet new reality? In Rembrandt, nothing is a stable surface. Even that thick paste heaped, scratched, smoothed, and once again covered up, which one notices above all on details of clothes (especially the sleeves of the characters in the *Jewish bride*, 1665, in the Rijksmuseum; or the *Family portrait*, 1668-9, in Brunswick; or his own self-portrait in Cologne; or the bedspread of *Bathsheba*, 1654, in the Louvre). Light glides over these impastos, almost as if reflected by a mirror, until the colored heaps vanish, like magic islands, into the shadow. And if the latter, because of its fluidity, remains without doubt the ideal expression of constant transition, it is at the level of the dissolution of matter that the phenomenon of interior movement better realizes itself, in an hallucinating alchemy of constant transmutations: light is the final gold. Even when Rembrandt contrasts two different areas, like thickness and gloss, as for instance on the right shoulder of *Hendrickje bathing*, there is transition, created by trails of color or by the penetration, in the margin, of one layer into another. It is a fusion of the oily substance according to that *morbidezza* mentioned by Vasari, but which

42

Rembrandt totally transforms: see for instance the contour of the woman's right side which seems to float between two surfaces so that the underside appears through.

Rembrandt also experimented with depth, following a technique much used by his predecessors and refined by Leonardo and the Venetians. One could even venture that the whole of Rembrandt's universe manifests itself in these hallucinating confrontations between *strata* or colored masses, covered or interspersed with glazing, worked at to exhaustion, and all to create here a crust full of life, here a surface crushed like some mysterious pond: such is the mirror of water in *Hendrickje bathing*, or the surface of so many backgrounds, as in *Jacob blessing the children of Joseph* (1656), in Kassel. Both abstraction and dream, all this pictorial substance seems to be full of a strange life which evades even the ordinary techniques.

On the other hand, Rembrandt does use *extra-pictorial* means, for his time, when he impresses all sorts of strokes with the tip of the handle of his brush, as in his self-portrait of 1629, in Munich, or in the portrait of his mother in Kassel. In his view, despite his highly sophisticated technique, pictorial matter is no longer a definition of form and space; it exists in itself, enlivened by a special movement and consisting of all kinds of elements which may occasionally look like a stammering or an

afterthought. It is from such grinding and kneading that this painter derives new meaning as he confers onto those scrapings, scratchings and all kinds of differentiation in matter the status of a particular technique, the poetry of which appears in the depiction of a slab of wood (Titus' desk in the Boymans Museum) as much as in so many backgrounds, like the one to *The conspiracy of Julius Civilis* where matter shines in a hallucinatory way.

Although reality in itself, depicted as a universe constantly dissolving and reforming, this pictorial matter of Rembrandt's is the highest and most necessary embodiment of his vision of a world in perpetual transition, even transmigration, through a complexity of transmutations which become, in all his works, the psychic embodiment of a feeling of passage. But then he saw life itself as a passage. And here one could enter into useless comments on his prodigality and lack of forethought. He was an artist, entirely devoted to his vocation, proud of the nature of a profession which placed him in high esteem in the eyes of everybody. He constantly fed on a prodigious imagination which he kept teeming with a whole collection of objects capable of suggesting to him a whole mythical, internal universe. What should one make of these multiple signs of a *passage*? Is it a passage towards death? One could easily assume this from the often melancholic looks of his figures, from the wide shadows— 44

almost symbols of the end of life and of the announcement of another world—and from a marked absence of youth. All this may well indicate the unavoidable direction of all the turmoil of our life, in conformity with a certain religious attitude. Without doubt, in order to understand Rembrandt better, one should go back to the Gospel according to St. John ('Light came forth from the shadow') within the context of the eternally new beginning suggested by his pictorialism. It is probably because of this that his work may appear to us as another kind of battle between Jacob and the Angel. Yet, let us look for the last time at the *Christ at Emmaus* in the Louvre, the symbol of a vision the reality of which is confirmed by the whole of Rembrandt's work. Do we not have here the most radiant and the most nostalgic vision of a transition of light which can only be grasped in the entirety of its symbolic presence when considered in relation to shadow?

Criticism and life

Simon Monneret

We know very little indeed of Rembrandt himself, his personal life, his feelings, his personality or his artistic theories. There is no correspondence, whether public or private, only a few letters regarding the commission for a painting of the Passion for the Prince of Orange, Frederick Henry of Nassau. Was there ever anything written by his hand, now lost, or did he express himself with his brush as others have done with their pen? Horst Gerson wrote that 'Rembrandt's art embraced worlds which not only totally excluded the critics of his time but which he could not express in theory.' And yet we think we know Rembrandt, all too well.

His works will always tell us more than any criticism; the latter does change according to the dictates of science and intuition, and is in turn biographical or technical, romantic, iconographic, formal or spiritual. During the 17th and 18th centuries, academic criticism is entirely divided on the subject of Rembrandt. Roger de Piles wrote: 'One will not find in Rembrandt either Raphael's taste, or that for antiquity, nor poetical thought or elegant drawing; one will only find what the instincts of his own country, linked with a fervid imagination, are capable of producing. He sometimes succeeded in transcending its baseness thanks to a stroke of genius, but as he knew nothing of proportions he fell easy prey to the bad taste he was accustomed

to.' And Dandre-Bardon warned his pupils: 'Do not look for the sublime in the compositions of Rimbran.'

Rembrandt was more admired for his engravings and etchings (probably because they enjoyed greater and easier distribution) than for his paintings. They were disliked for the same reason they are admired today: their violent touches, their thick colors, the almost total lack of drawing, the sumptuous bad taste of the heavy and sombre costumes, the freedom of that light coming from no one knows where. Nevertheless, the majority of critics agreed with Roger de Piles that, seen from a distance, Rembrandt's paintings 'appear as uniform works in the perfection of the strokes and the attunement of the colors', although they do not achieve the mellow tones of Titian. And they recognized 'the supreme cleverness' of his chiaroscuro. It is not surprising that de Piles should have judged Rembrandt's paintings more justly than others: after all he defended the value of color against Le Brun and placed accurate drawing below other plastic values.

During the 19th century a new myth was born, that of a Rembrandt whose life was troubled by a number of misfortunes: the death of his wife, bankruptcy, sale at auction of his collections and his house, estrangement of friends, loss of fame and decline in commissions. Rembrandt would have died

alone and in penury after having extolled in his art what he could not achieve in everyday life. We know now that the end of his life was not quite as unhappy as the Romantics thought. Even if his art was no longer attuned to the ideas of the Holland of the 1660s, he still had pupils and several commissions; and his death was no more and no less lonely than that of other painters of the day. The Romantic artists were fascinated by two aspects: the common man and the visionary artist. A Rembrandt full of sympathy for the poor, the aged, the sick, the Jewish merchants, could not fail to seduce George Sand and Victor Hugo. Baudelaire wrote about him: 'Rembrandt is a sad hospital full of whispers and lit only by a wintry light.' And as for his characters: 'they are taken from the Jewry, the frippery, the theater or the bohemian circles . . . emerging from a dream, they are dressed in the most singular fashions in the world' as Fromentin said about the little girl who appears in *Night watch*.

Rembrandt's first biographers had already given credit to these interpretations when they reproached him for his coarse style. Filippo Baldinucci wrote at the end of the 17th century: 'He was a bizarre person, who scorned everyone. The graceless and unpolished face which afflicted him was matched by a neglected and dirty appearance; it was his habit, while painting, to dry his brushes on himself, and he was the

same in other things. When he worked he would not give audience to a king, who would have had to come back again and again until he found him free of work. He often went to public auctions where he bought out-of-fashion clothes, which seemed to him weird and picturesque; and even if they were thoroughly filthy, he would hang them on the walls of his studio among the beautiful things he loved to collect . . .'

And to this day, Dominique Fernandez, in his psychoanalysis of van Gogh and Rembrandt, writes: 'Their canvasses are thick, never polished. Somehow ill-dressed, like their authors, and like the freaks for whom they could act as godfathers.'

Of his style, Delacroix wrote in 1851: 'Perhaps some will find that Rembrandt is an even greater painter than Raphael . . . I find, as I get on in life, that there are better and rarer things.' And van Gogh saw in Rembrandt a spiritual realism. 'I can show you a painter who dreams and paints with his imagination; and yet I started by assuming that what is typical of the Dutch is that they have no imagination, no fantasy, and invent nothing. Am I illogical? No. Rembrandt has invented nothing, and as for that angel and that strange Christ, well, he knew them, he felt them to be there.' Today one settles for a more profane and prosaic interpretation of Rembrandt's work. One

can show, from the list of his collections and drawing books, from the influence of his masters and teachers, that he knew not only of Caravaggio and Rubens but also of Leonardo, Raphael and Giorgione. And one can say with Kenneth Clark that 'the real ancestors of Rembrandt were Masaccio and Donatello'; even though Rembrandt always refused to go to Italy, which, in the 17th century, completed the training of Dutch painters.

Thus Rembrandt's style became diversified. In his first works he wanted to break away from academic laws and instil more life into historical painting. He tried to do this, rather clumsily, in the *Martyrdom of St. Stephen*, of 1625. In reacting to Lastman's sentimentality and pathos, he used exaggerated colors, movements which seem too violent and confer to his paintings a swollen artlessness. Towards 1628-9 he absorbed the influence of Caravaggio through the Utrecht School (Terbruggen and Honthorst). The *Christ at Emmaus* of 1628 typifies the

THE MANY FACETS OF REMBRANDT

abandonment of too vivid colors, the exploitation of the dramatic effects of light, the technique of impasto to enliven space, and the realism of gestures to express the feelings of the pilgrims.

The 1630s are the years of a baroque style which disregards light in preference to decorative sumptuousness (*The rape of Proserpine*); or underlines the most veracious and crude details, like the screaming and urinating child in *The abduction of Ganymede*; or, as in *The descent from the cross* of 1634 and *The entombment of Christ*, stresses sorrow and tragedy by chiaroscuro and the heaviness of Christ's dead body which shows a human death rather than that of a God. Rubens outstripped life and beauty in the shapes of his bodies, Rembrandt underlined the ugliness of death and the fragility of the ageing body.

From the body of Christ to that of *The anatomy lesson* of 1632, Rembrandt developed his sense of monumentality, his sense of the dialectic of movement, enlivened here by the glances of the professor and his students pursuing the interrogation of life and death. For the first time the painter is aware of the reversibility of portrait and history: the portrait can create a 'happening', history can be told only with men. Rembrandt's contemporaries were aware of this ambivalence, since they did not regard him as an historical painter. The mythological and oriental costumes, or, towards the middle of the '30s, the 54

Venetian ones in which he depicted Saskia or himself, are not pure fantasy. They betray the effort to dress everyday reality with an ulterior truth. A dream of nobility on the part of a middle-class man? A dream of a different reality? Perhaps a little of both.

The baroque decor requires a monumental construction. This alliance is clear in the *Night watch*. But by 1642 Rembrandt has already left Baroque behind; the *Night watch* is an exception, and when, in the '50s, he will go back to a heroic architecture, this will be integrated with a thoroughly personal vision in which the Baroque remains peripheral.

During the '40s, under the influence of Raphael and Titian, Rembrandt introduced serenity and dignity into his compositions. According to H. Gerson, this evolution follows the stylistic tendencies of his day and is not directly due to the misfortunes of his personal life (the death of Saskia in 1642). As Malraux put it, 'the painter is above all the product of his development as an artist, not as a man.' However, Rembrandt could have derived the serene amplitude and the harmony of forms of his landscape from nature, which he had already been copying in his drawings. The male portraits (*Portrait of a Jew*, 1647), the saints, the Christs of 1650, lose their exotic character and take on a more human dimension. The themes of the histori-

cal paintings are more suited to intimacy and sweetness than violence and drama; he painted *The adoration of the shepherds* and *The reconciliation of David and Absalom*. This feeling for moderation is quite clear when one compares the new version of the *Christ at Emmaus* (1648) with the old one.

To paint a quartered ox like a nude and a nude like a monument: the more one sees of Rembrandt's work, the more the characters increase in importance to the detriment of narrative and baroque details. The *Danae,* painted in 1636 and retouched towards 1650, still shows the baroque splendor of the period. Quite the reverse with *Bathsheba,* in which, as shown by the preliminary drawings, Rembrandt is more preoccupied with the composition of shapes and relationship of colors than with the historical narrative and the picturesque details. In the *Young girl at a window* (1651), in *Hendrickje bathing in a river* (1655), the forceful strokes, the width and depth of the layers of paint, the firmness of the model, the tendency to reduce design to geometrical shapes, confer to the nude and the portrait a heroic presence which makes them stand out from the canvas. The artist built his composition with masses of color and light and also with human shapes. It is his personal interpretation of Venetian art, particularly Titian, his contribution to the monumental nobility which characterizes Dutch art in the '50s

(*Portrait of a man* by Hals, *The Castle of Bentheim* by Ruysdael). And it is with this technique, not just with his internal light, that Rembrandt will seduce the moderns, from Delacroix to van Gogh, from Cézanne to Rouault. His forms are solid and compact, but with a different geometry from those of Raphael; they are fluid and luminous but with a different transparency from those of Duccio or Masaccio. As he grows older, this contradiction becomes the double manifestation of integral power of expression. *St. Matthew and the Angel* (1661) and *The conspiracy of Julius Civilis* (1661) on the one hand, *The circumcision of Christ* and *The Jewish bride* (1665) on the other, show how, during the last years of Rembrandt's life, the profane and the sacred, the human and the superhuman, the power of gold and the light of the soul all intermingle.

There are in Rembrandt some constantly

recurring themes: those of ageing and death (self-portraits, *The*

descent from the cross, The anatomy lesson); of sight and blindness (*Tobias healing his father's blindness*, 1636; *The blinding of Samson*, 1636; *Aristotle contemplating the bust of Homer*, 1653; *The conspiracy of Julius Civilis*, 1661); of apparition and absence (*The resurrection of Lazarus, Christ at Emmaus, Danae*); of wounding and enchainment (*Andromeda chained to the rock*, 1631; *The sacrifice of Isaac*, 1635; *The slaughtered ox*, 1655; *The suicide of Lucretia*, 1664); of the embrace and the oath (*The return of the prodigal son*, 1668; *St. Matthew and the Angel*, 1661; *The night watch*, 1642; *The Syndics of the cloth-makers' guild*, 1662). These are the themes which punctuate Rembrandt's visionary world. Each one of them could be the subject of a special study; even if Rembrandt has drawn them from the classical repertoire of religious painting, his choice symbolizes a personal orientation. They define a certain dramatic world which has been compared in intensity with that of Shakespeare.

There are also certain other questions we ask ourselves about Rembrandt: what was his faith or religious affiliation? Should one regard him as the representative of the desire for experimental knowledge or of the constitution of a moral or psychological individualism? Are his paintings of graceless bodies and aged faces the expression of his mysoginous temperament or of the search for another reality? We can answer

these questions with iconographical, sociological, psychoanalytical or philosophical considerations. One can also try to explain Rembrandt from the point of view of the historical and ideological conditioning of 17th century Holland. As F. Schmidt-Degener said, 'his creations reflected a European evolution, which was itself plagued by internal contradictions.' From this point of view, Rembrandt was subjected to the treble influence of the baroque ideology of the Court, of the middle-class merchants and of the protestant church. The marxist interpretation of Hadjinicolau contends that 'one should forget Rembrandt if one wants to explain the images he produced.' On the other hand, Huyghe showed how Rembrandt can be explained not only by his century, but also according to a personal spiritual evolution which distinguished him from the other artists of his day: 'He was the only one to rediscover the path indicated by the great mystics, the path which disappears into the night to discover, on the other side, a different light, the source of which is no longer physical.' As for Dominique Fernandez, he sees in Rembrandt a rather nice neurotic. 'His taste for disguise, for masquerading, for jewels, for lonely walks far from the domestic hearth into suspect quarters where he enjoyed doubtful company, reveals the need to punish himself for a sin which deserves severe chastisement. The feminine body is the object now of a deform-

59

ing caricature, now of a childish idealization; the fear of woman and the anguish of castration. And it is now no longer difficult to diagnose: Rembrandt does not only place himself on the border of the middle class economic order, he also cheats the sexual laws of the ruling class.'

Each of these interpretations has its attractions. Nevertheless they are often inadequate; and some are untrustworthy from the point of view of the art historian. We are not here to criticize them, but to show that Rembrandt is also quite close to our way of feeling and enjoying painting as art, as close as he is to that interior vision which has often been attributed to him. He was certainly a dissident *vis-à-vis* orthodox Calvinism; he sympathized with religious groups such as the Arminians or the Mennonites who believed in baptism at the age of thirty, and this explains his interest in the depiction of Biblical texts. But his relationship with protestant ethics is not simple. Amsterdam was then a tolerant city where gentiles and Jews lived side by side, and he adopted this tolerance, as shown by *The Syndics of the cloth-makers' guild*, in which each character belongs to a different confession.

Amsterdam was also the city of Descartes and Spinoza. Emmanuel Berl wrote: 'Rembrandt is as abrupt and unsettled as Spinoza is peaceful and uniform. Spinoza is all under-

standing and reasoning, Rembrandt all emotion and intuition. But they meet in the same obsession with God, in the same love for the world.' Yet the opposition between the conceptual and the intuitive is too general to characterize Rembrandt. The mystical interpretations of his personality have always been based on his sense of sight and his effects of light. His sense of touch and his effects of impasto are just as important. Therefore, one may well ask whether, when one steps back to look at one of his canvasses, one is not obeying a moral need to belittle the senses which is not only typical of protestant style but which already characterized the religious painting of the Italian Renaissance.

Rembrandt did not invent chiaroscuro; neither did he invent transparency; however, he did destroy classical perspective by creating a new way of perceiving the world through the senses. Yet, when he copied *The Last Supper* by Leonardo he demolished its perspective. When he drew inspiration from Raphael (*Self-portrait*, 1640) or from Titian (*Danae*), he did not retain the classical proportions of the human figure. When he picked up some theme from Rubens (*The abduction of Ganymede, The descent from the cross*) he changed the ideal beauty into a material beauty. Unattractiveness is only an approximation of the latter. Rembrandt painted badly, but on purpose. The

further he progressed in his work, the less did he take academic rules into account. He left out secondary characters, the outlines, the decoration; he painted coarsely the bodies, the hands of his characters; so much so that his client Don Antonio Ruffo sent back some paintings asking him to finish them. One wonders what would have happened if the artist had lived longer, whether perhaps the faces themselves, always so finely polished, like the one of the Jewish bride, would not have disappeared from his works. The reason why there are so many old men in his pictures is, also, because their faces lent themselves well to his pictorial poetry. In an age when the individual became king, when morality had to shed the body in order to gain access to God, Rembrandt spoke the language of plasticism in revolt. He re-created the organization of forms according to masses of light and shadow, and the transparency of light in terms of effects of color and impasto. His light is tangible, like the rocks and ruins of his landscapes. If he was a mystic, it was not only in the dead expression of his faces that he built his hermitage, but in the desert of their textures.

II

Rembrandt by himself

PLATES

Notes by Simon Monneret

At the age of 23, Rembrandt had already completed his formation as a painter. He had his own studio at Leyden, which he shared with his friend Jan Lievens. He was primarily a historical painter and had not yet executed his expressive and lively portraits of the Dutch middle classes which brought him fame. His first portraits show his mother and father, and himself.

The self-portraits of the '20s are at the same time stylistic exercises for the characters of his historical paintings and the psychological research of a young man of unstable identity. Rembrandt tried to grasp in the mirror the complexity of his physiognomy in order better to depict the real character of his subjects. There are two kinds of portraits: one depicting the Rembrandt son of a miller, his peasant features violent or cheerful; the other, to which this portrait belongs, showing an ideal Rembrandt, who had recently joined the merchants and intellectuals of Amsterdam.

Impetuosity, determination to get far, are here expressed by the chiaroscuro which divides the face into two parts. Influence of Caravaggio, but also Rembrandt's questioning of the opposition between night and day. This small portrait, polished like a miniature, shows that Rembrandt can rival the traditional Dutch realists.

SELF-PORTRAIT
1629: 37.5 × 29 cm
The Hague, Mauritshuis 64

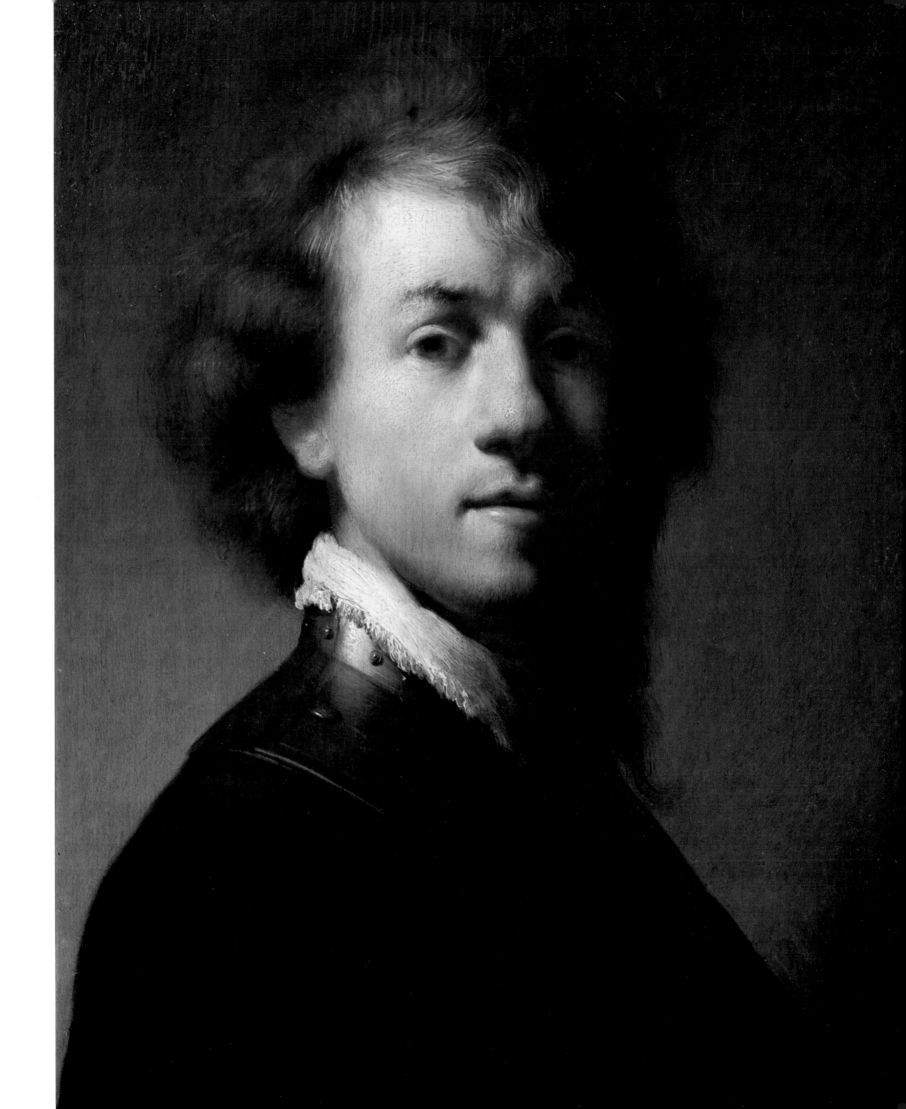

Towards the end of the '30s Dutch painting shows a withdrawal from the Baroque. Tones become monochromatic, the narrative loses some of its emphasis and theatricality to become more sober. Rembrandt joins in the trend. In his pictures of Prophets and Saints from the Old and the New Testaments he achieves a balance between historical painting and the intimate style of the pictures of interiors which are traditional in Flanders and in Holland.

The objects and the decoration are painted in great detail but their realism is attenuated by the luminous halo diffused over the picture. The clearly defined chiaroscuro of the preceding years has been replaced by a diffused light which is propagated by the surface of the objects. The depth of space, the height of the vault communicate the feeling of a humanity at the same time near and far away. The window does not open on the outside but on the divine life of the Saint.

A SCHOLAR IN A LOFTY ROOM
1631: 60 × 48 cm
Stockholm, Nationalmuseum 66

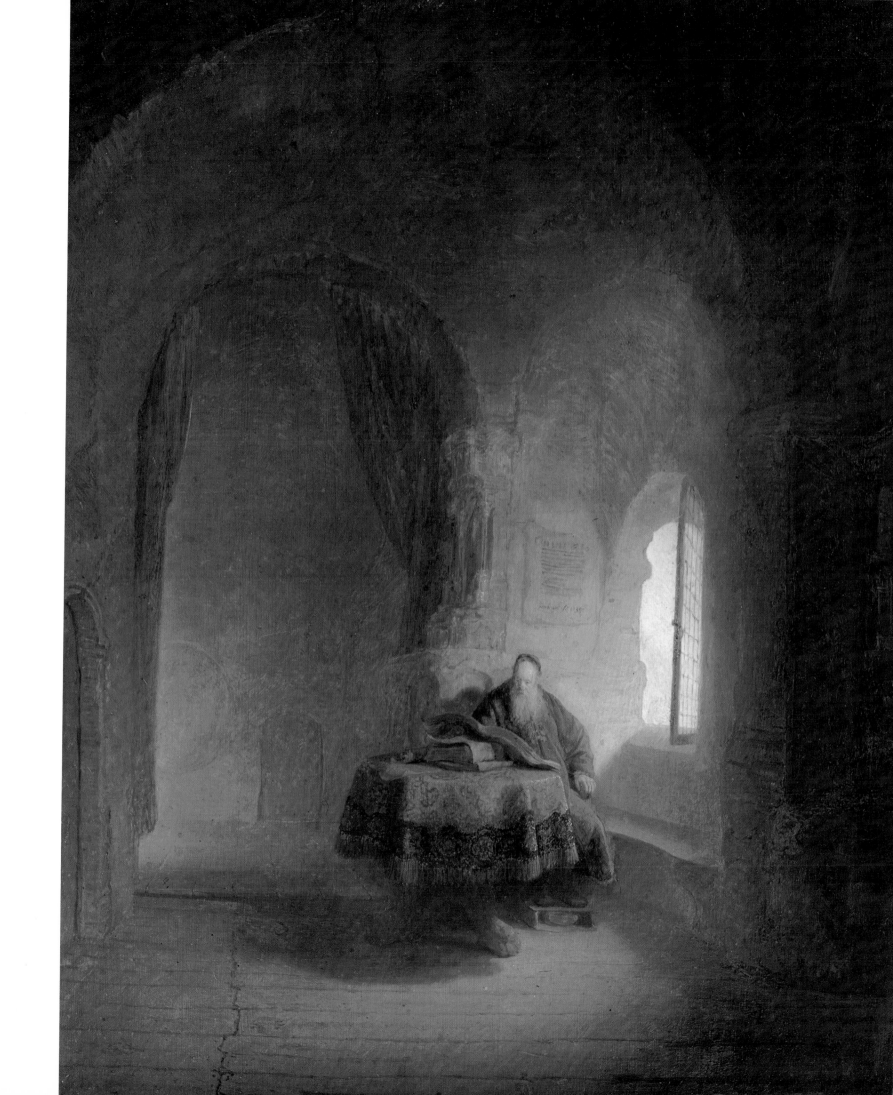

Rembrandt painted relatively few landscapes by comparison with the historical pictures or the portraits. And yet landscape was, in 17th-century Holland, a genre highly thought of, perhaps because of the scientific discoveries of nature. Landscape painting then obeyed the rules of detailed realism, as for instance in the young Jan van Goyen. Rembrandt drew from an older tradition, that of the fantastic landscape which he had discovered in Hercules Seghers and which will occasionally be found again in Bruegel. These imaginary landscapes had their mannerist version in Roelant Savery and Govaert Jansz. From the Mannerists Rembrandt took the luxuriant vegetation, from Seghers the rocky, naked landscapes. In *Stormy landscape with the good Samaritan* religious painting coexists with the landscape, but one does not know which has transfigured the other. If the actual tale is lost in the landscape, the latter has acquired expressive and symbolic power.

On 29 July 1854, Delacroix wrote in his Journal: 'The landscapes of Rembrandt, Titian, Poussin are generally in harmony with their figures. In Rembrandt, and this is perfection, the background and the figure are one and the same. Everything is interesting: one does not separate anything, as in a beautiful view offered by nature in which everything contributes to enchant one.'

STORMY LANDSCAPE WITH THE GOOD SAMARITAN
1638: 46.5 × 66 cm
Cracow, Czartoryski Museum 68

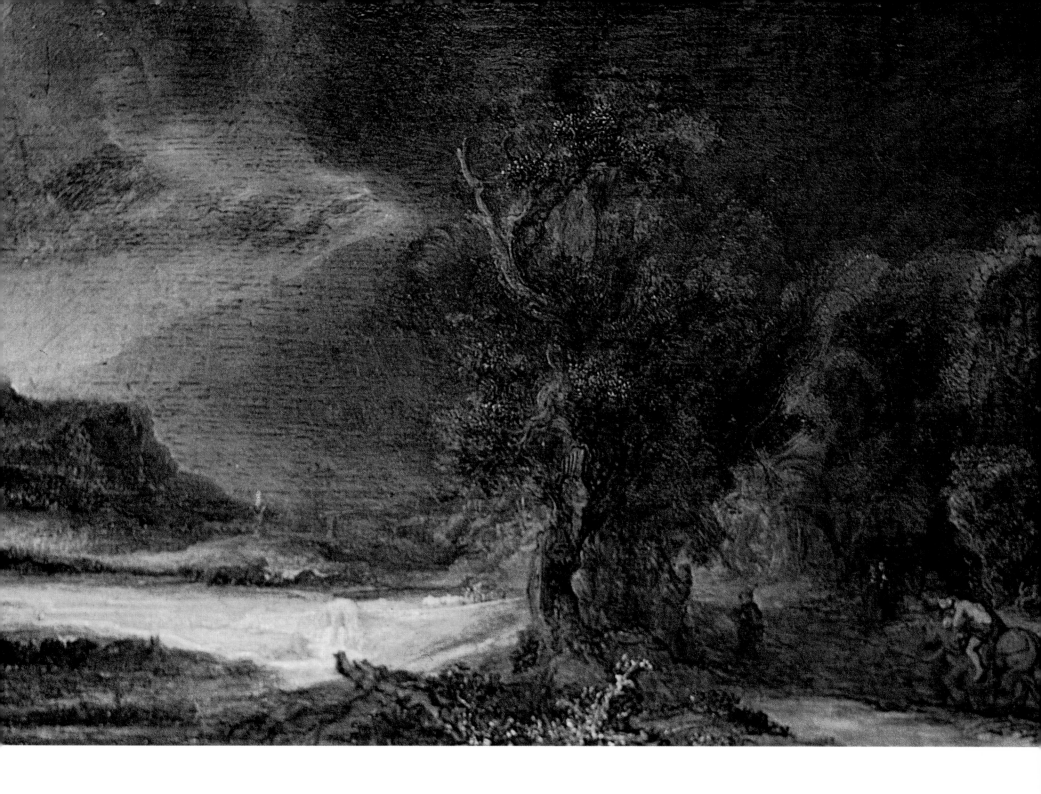

At about 25, while still living in Leyden, Rembrandt received his first important commission, thanks to Constantijn Huyghens, secretary of the Stadholder Frederick Henry. The latter commissioned a series of paintings depicting the Passion, including an *Erection of the cross*, a *Descent from the cross*, an *Entombment*, a *Resurrection* and an *Ascension*. Rembrandt spent several years on the commission. In the first pictures he searched for a dramatic expression which could rival in style with the tormented shapes so dear to Rubens.

The influence of the calm vision of Titian is apparent in *The entombment of Christ*. The Glasgow version is like the 'negative' in brown of the painting executed for Frederick Henry. It was probably a rough draft in monochrome for an engraving never executed. In this Rembrandt followed the example of Rubens who would popularize his works through the distribution of engravings.

The only one of Rembrandt's letters which contains some sort of judgement on his own art refers to this *Entombment* and to the *Resurrection*. 'In these two paintings' he wrote, 'I tried to keep the movement as natural as possible; that is why I took so long over them.' In the *Entombment* the pyramidal movement of the figures is inversely reflected from right to left and the white heaviness of the body of Christ almost attracts the group towards the tomb. The calm emotion of the scene is due both to the dynamic composition and to the chiaroscuro.

THE ENTOMBMENT OF CHRIST
1639: 32.2 × 40.5 cm
Glasgow, Hunterian Museum (University) 70

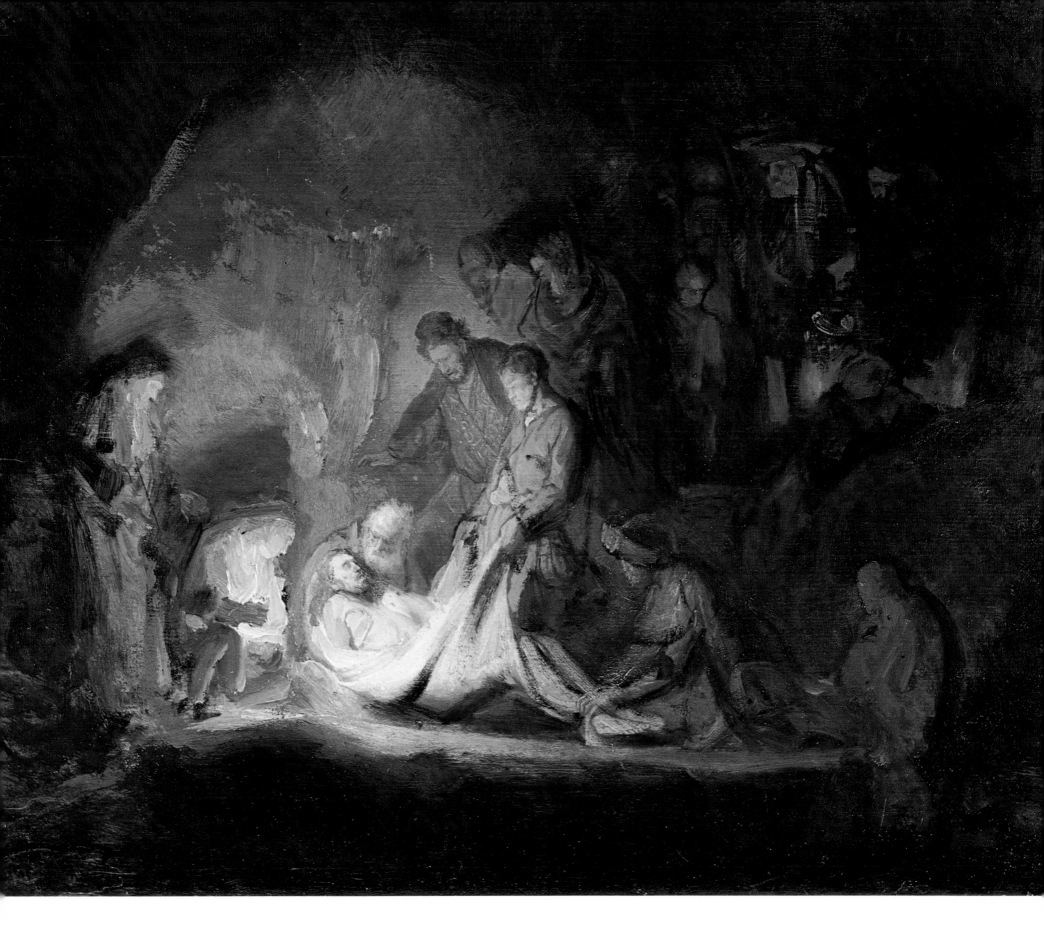

One finds Rembrandt's mother again in the features of the prophetess Anne; he would also paint his own features in his historical pictures, to give them a feeling of actuality. This ambiguity between present and past will become even more marked in his last works. The appeal of the aged to Rembrandt coincided with that of the Bible. His interest was both personal and necessitated by historical painting, but he turned it into a study of human psychology which goes beyond the exegesis of the Scriptures. The calm and inner serenity of his mother's face contrasts with his first works, in which drama is expressed through external movements.

Rembrandt works his impasto in depth and does not hesitate to scrape and scratch with the handle of his brush to add relief to his portraits.

REMBRANDT'S MOTHER
1630: 35× 29 cm
Essen, von Bolen und Halbach Collection 72

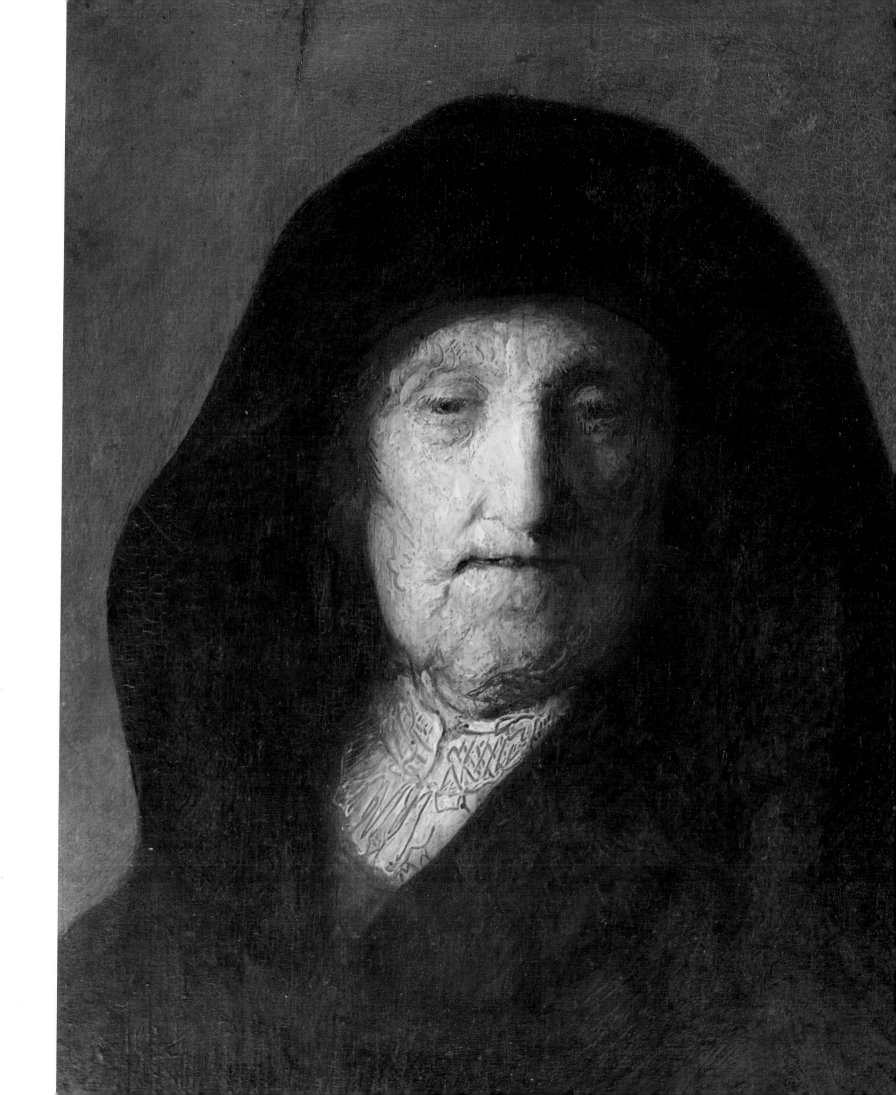

Rembrandt always depicted Biblical characters in Oriental costumes; he owned a collection of precious objects and exotic finery with which he dressed up his models. From 1640, drama is no longer expressed by gestures or the expressiveness of lines, as in Rubens, but through the harmony of forms. In this painting (bought by Catherine II with the Walpole collection) the same curve envelopes the two characters while the verticality of the stone wall and the solidity of the masses of the castle in the background stress the solemnity of the moment. The harmonious distribution of the chiaroscuro and the warmth of the golden tones reinforce this impression while at the same time bringing the embrace of the two men closer to us.

THE RECONCILATION OF DAVID AND ABSALOM
1642: 73 × 61.5 cm
Leningrad, Hermitage 74

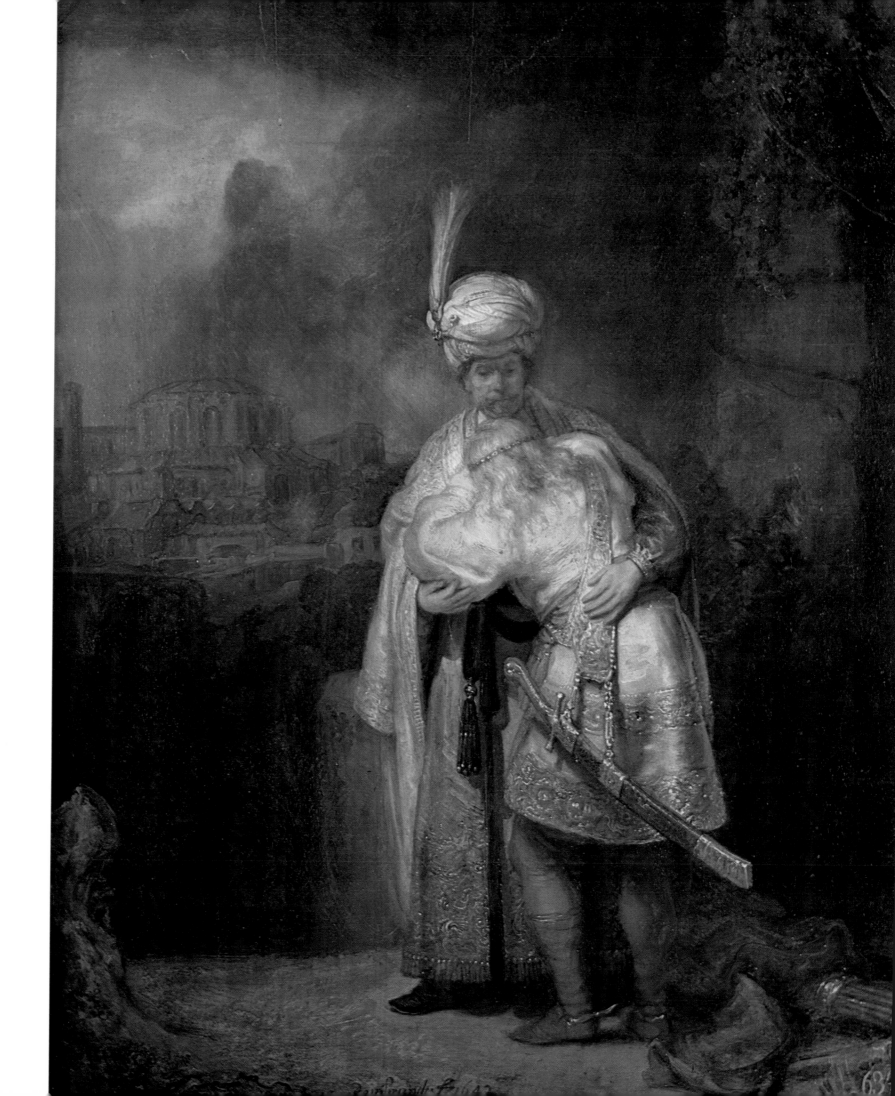

In the '40s Rembrandt's self-portraits had been influenced by those of Italian artists, such as Raphael's *Baldassarre Castiglione*. During the '50s there are still traces of this influence in the noble postures and sometimes in the details of clothes, wide-brimmed hats and sophisticated costumes. There are however many differences: his face begins to occupy more and more space, the intensity of the light is concentrated mainly on the eyes and the forehead.

Rembrandt is now 51, a rather more advanced age in the 17th century than nowadays. However, Rembrandt seems to be blaming his own features for showing old age. The penetrating eyes stare at themselves in the mirror as if to question the reality of this ageing. The questioning of time underlines in Rembrandt the spiritual achievement of humanity.

SELF-PORTRAIT
1657: 49.2 × 41 cm
Vienna, Kunsthistorisches Museum

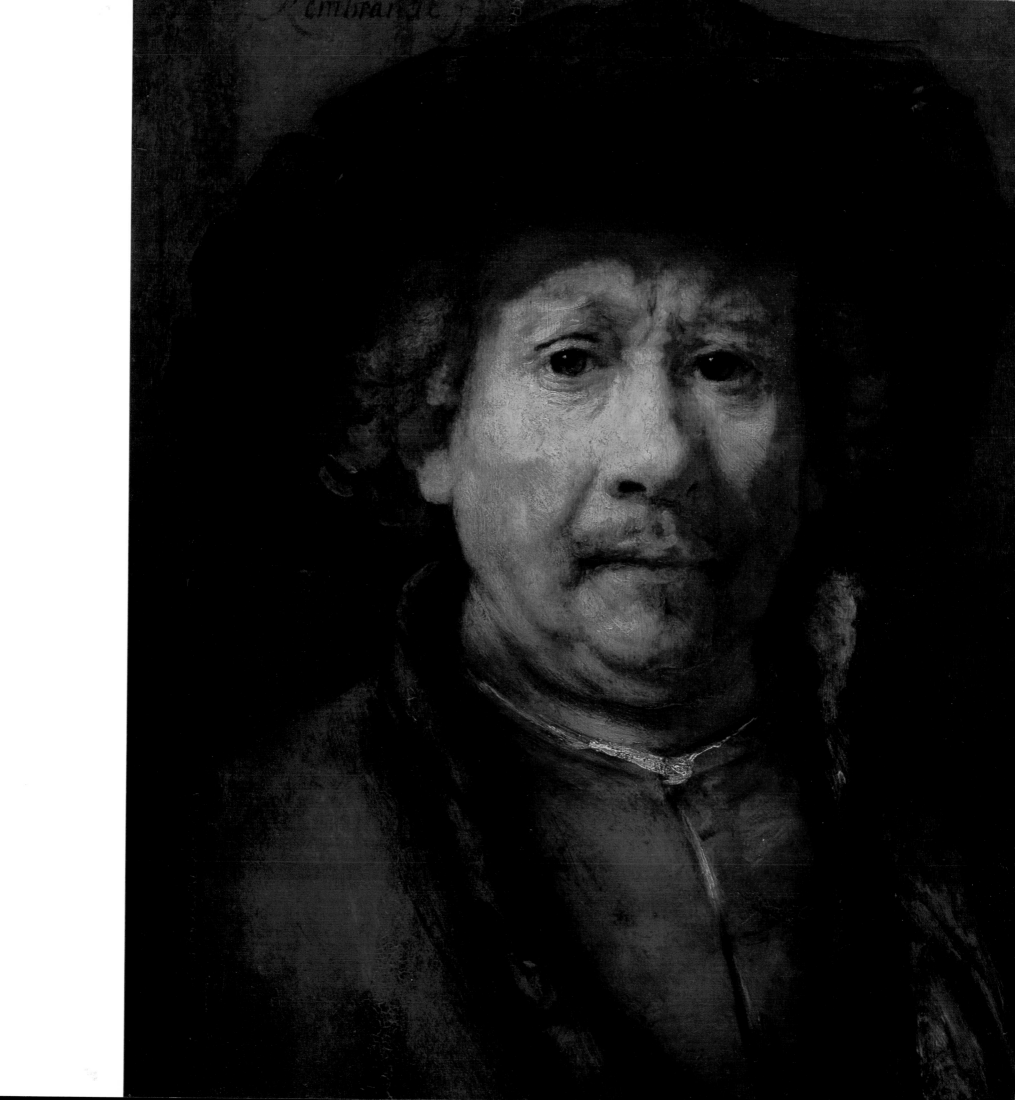

Motifs like the arches of the stone bridge, the obelisk or the old ruins are inspired by Italian classical tradition, which Rembrandt might have absorbed through the work of Titian and Giorgione, having been introduced to them by Elsheimer. This small picture, in which the reddish-brown tones of the wood are mixed with luminous colors, represents a plastic research on atmospheric perspective. Rembrandt is here studying the combined effects of water, air and light.

STORMY LANDSCAPE WITH AN ARCHED BRIDGE
1638: 28 × 40 cm
Berlin-Dahlem, Gemäldegalerie 78

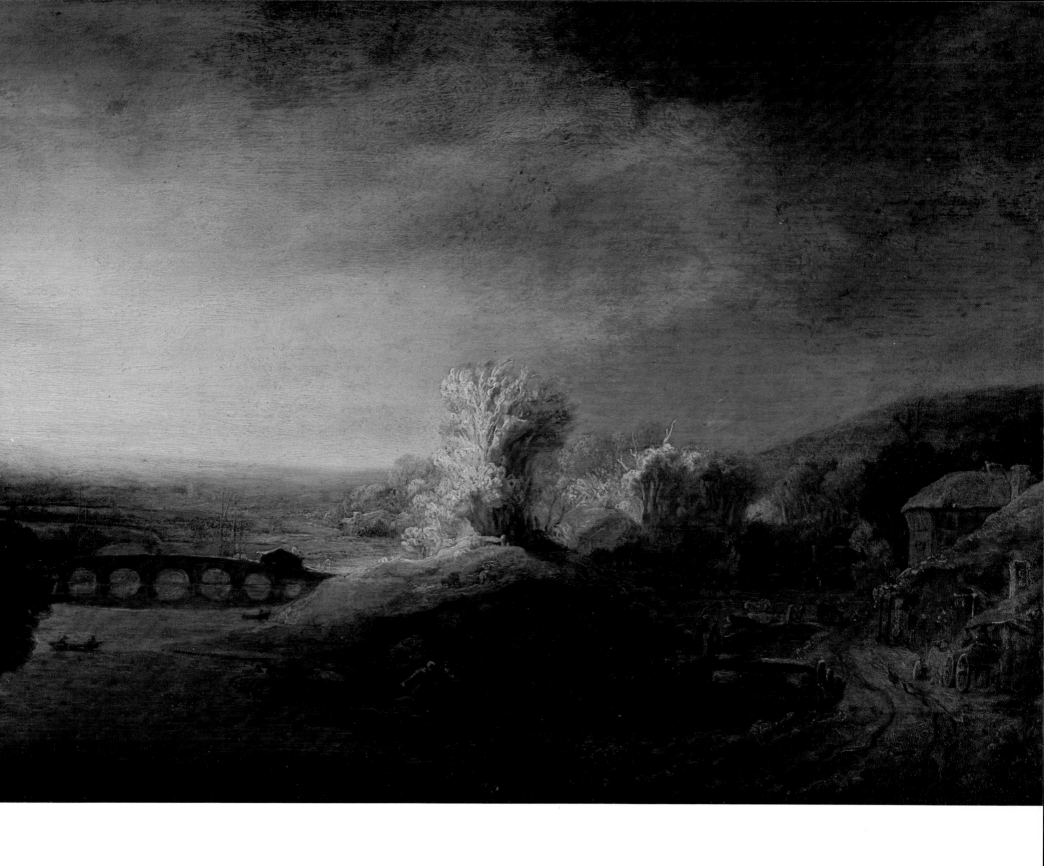

THE NIGHT WATCH
1642: 363 × 437 cm
Amsterdam, Rijksmuseum

The night watch is less a night patrol than the portrait of a group of civic guards, as shown by its original title: *The militia company of Captain Frans Banning Cocq and his lieutenant Willem van Ruytenburgch marching out.*

The painting was commissioned by the Captain himself. The collective portrait was a common genre in the 17th century; Cornelius Ketel and Frans Hals also painted companies. But this particular work differs in many ways from those of other painters. More often than not, the guards were represented in a static position, not in movement; here, on the contrary, the company sets off marching at the sound of the drums and with a certain hurry, as witnessed by the different activities of the guards. The traditional gesture of the Captain introducing his company assumes here a different pictorial meaning: the arm almost juts out of the picture, it is given extra relief by its own shadow cast on the lieutenant and marks the extreme point of a movement born in the depth of the painting. The ascending and descending diagonals—the halberd of the lieutenant, the musket of the guard blowing on his powder and the halberd of another guard on the right, and on the left the musket of the guard charging it and the staff of the standard—stress the dynamism of the composition.

This movement, together with the powerful chiaroscuro which unites Captain and lieutenant, have contributed to rank this painting as the apogee of Rembrandt's baroque art of the 1630s. Nevertheless, *The night watch* also shows other influences and introduces the Rembrandt of his maturity. The classic proportion between the surrounding space and the figures firmly placed under an arch was probably inspired by Raphael's *Stanze* which Rembrandt had studied in engravings. The monumental aspect derived from the Italian Renaissance was even clearer before the painting was cut when moved to the Town Hall of Amsterdam in 1715. Finally, next to the chiaroscuro one already finds the transparency of colors which will appear in all its glory in Rembrandt's last paintings.

80

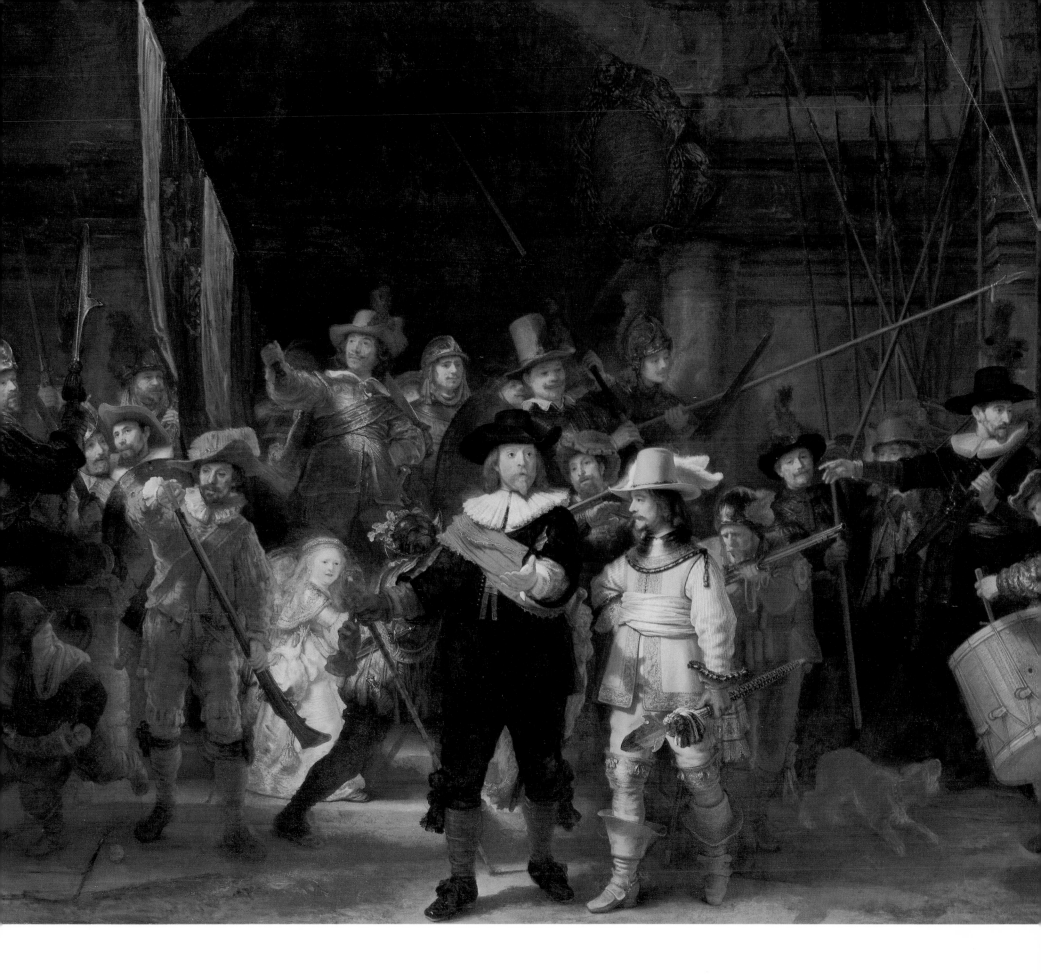

It is difficult to separate in this picture what is the fruit of the artist's imagination from what is due to contemporary reality or symbolic allegory. Are the picturesque costumes due to Rembrandt's taste or to that of the middle classes of his day? And the little girl who appears in a magic light; is she an allegory of victory or simply the bearer of the cock, the prize of the competition? Whatever the truth, she is proof of Rembrandt's tendency to introduce an element of strangeness in a too ordinary reality.

In the self-portraits of the last years of his life, Rembrandt leaves out all disguise and fantastic costumes, whether Oriental or Venetian, to depict himself with the attributes of a painter. In this self-portrait (the first Rembrandt to be added to the French royal collection) the palette in the left hand and the brush in the right contribute, with their suggestion of abstract lines, to the arrangement of space within the picture. The same can be observed in the portrait at Kenwood House, London, executed about the same time. Here we see for the first time the white cap, the luminosity of which contrasts with the sombre clothes. Only the few colors on the palette animate the dynamic space of the picture. Rembrandt's face has grown older but his transparent glance, both restless and absent, allows one to foresee the reality beyond.

SELF-PORTRAIT
1660: 111 × 85 cm
Paris, Louvre 82

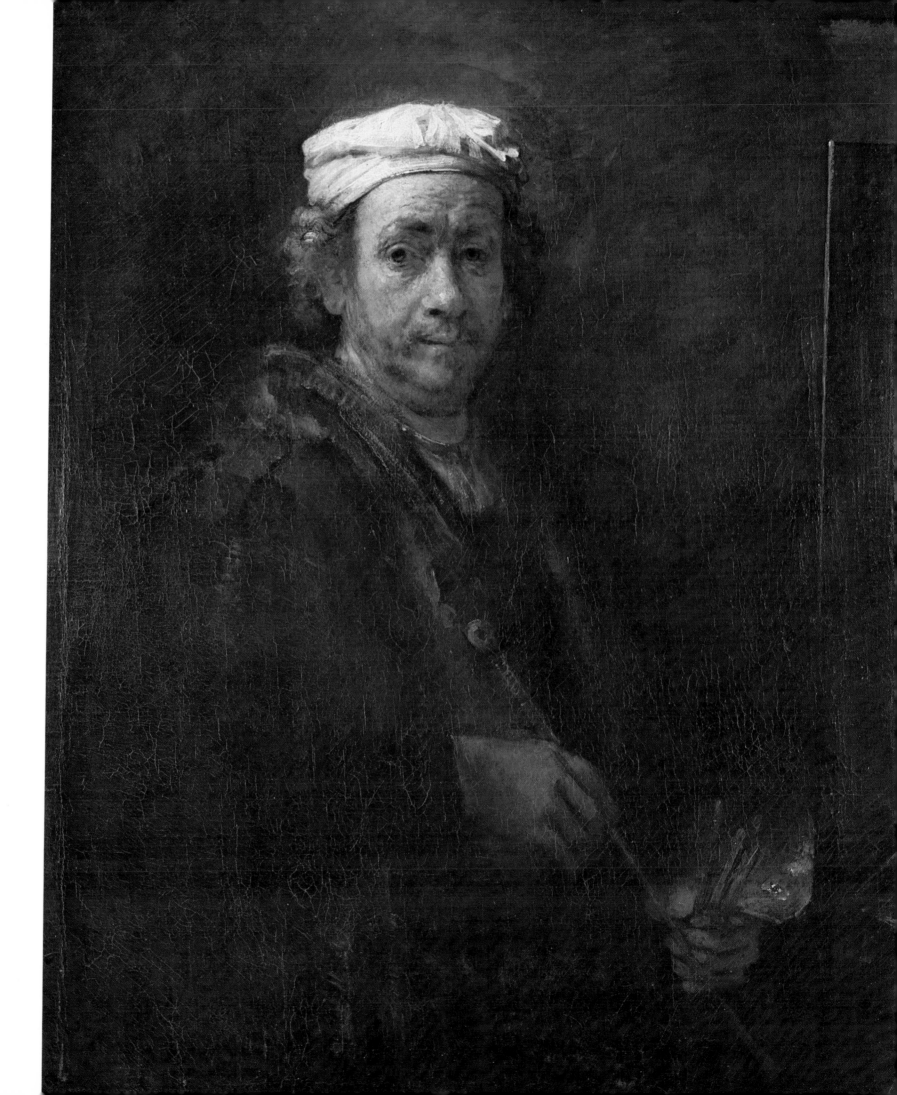

Jews played a double role in Rembrandt's world: as part of his interest in the Old and New Testaments and in his everyday life. He lived for a long time near the Jewish quarter of Amsterdam, in his beautiful house on the Sint Anthoniesbreetstraat, and had many Jewish friends (intellectuals and merchants). He chose Jewish models when he wanted to represent religious scenes.

This portrait is an exercise towards the painting of Christ's face, often carried out at this period. Some of these portraits were painted together with scenes from His life, like *Christ at Emmaus*. In this particular portrait one finds the depiction of the face and the lowered eyes which often characterize the physiognomy of Jesus in Rembrandt's pictures.

PORTRAIT OF A YOUNG JEW
1647: 24.5 × 20.5 cm
Berlin-Dahlem, Gemäldegalerie 84

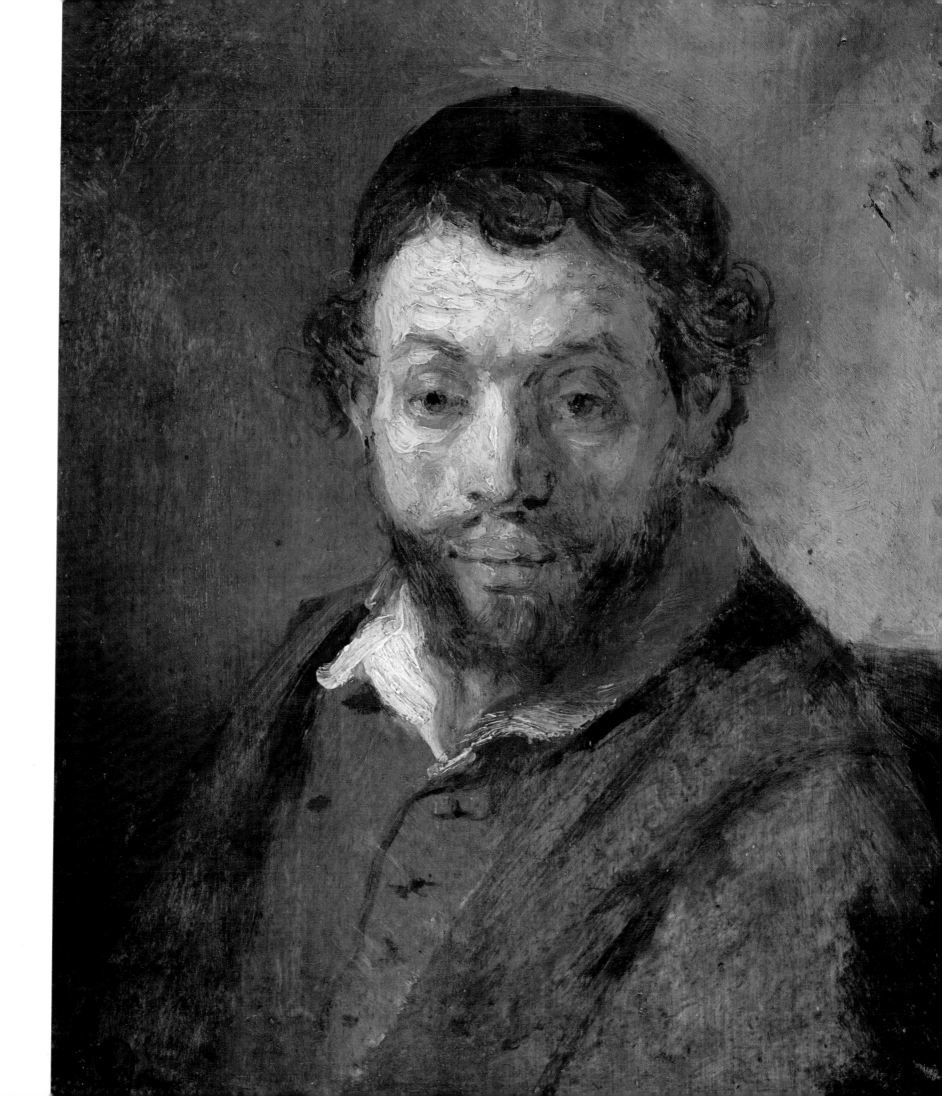

The contrast between the receding storm, which plunges nature into darkness as it goes, and the still pale and ghostly light which streams out of the clouds creates an apocalyptic feeling. In such a fugitive moment the celestial Jerusalem appeared to the eyes of the peasant still immersed in the night of the senses. These landscapes are small portions of Biblical paintings as well as appealing to our subconscious.

'The objects organized themselves not as they were in a certain actual order but according to the visionary imagination which gathers the elements suitable to the expression of the tragic contents, the ruins scattered here and there in the stormy landscape.' (Marcel Brion.)

STORMY LANDSCAPE
1639: 52 × 72 cm
Brunswick, Herzog Anton Ulrich Museum 86

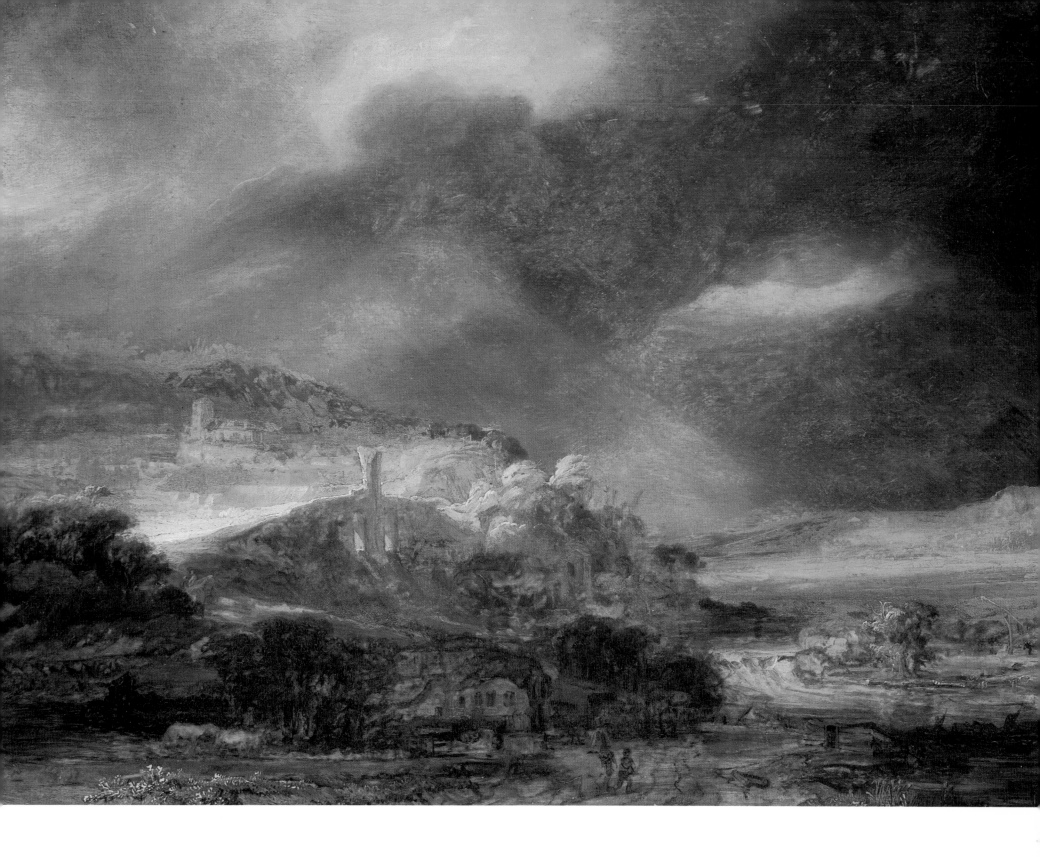

Twenty years earlier Rembrandt had already produced a fine version of this subject (Jacquemart Andrè Museum) in which the dramatic composition still showed the lesson learnt from Caravaggio. Christ and one of the disciples were caught in an oblique perspective divided into light and shade.

In the picture of 1648, one has to refer back to Leonardo's *Last Supper* and the perspective of the Renaissance. All dramatic action has vanished being replaced by harmony between the horizontal surface of the table and the vertical columns framing the niche. The emotion of the pilgrims who recognize Christ the moment He breaks the bread is delicately suggested by a slight movement of astonished withdrawal. Christ himself seems caught between the monumentality of the stone which symbolizes His power and His glory and the white table cloth reflecting His light.

The painter's power of transfiguration astonished the writers of the 19th century, and Baudelaire said: 'Raphael, however pure, is only material spirit in constant search for solidarity, but that Rembrandt is a powerful idealist who makes one dream and guess on the other world.'

CHRIST AT EMMAUS
1648: 68 × 65 cm
Paris, Louvre 88

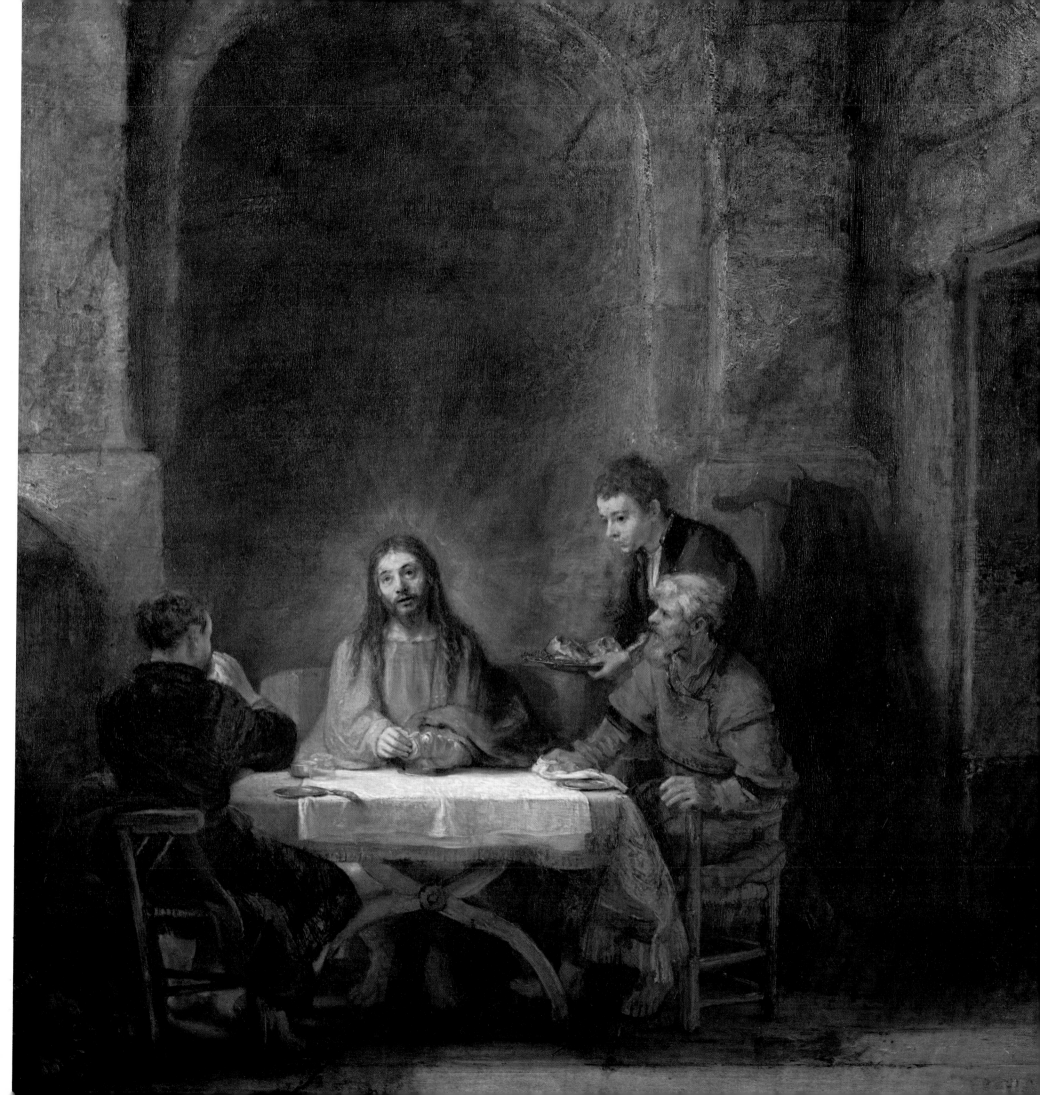

'The figure of Christ has been painted the way I feel it' said van Gogh in 1888, 'only by Rembrandt and Delacroix' and he added later in a letter to his brother Theo: 'In Rembrandt alone, or almost alone, can one find that tenderness in the looks of people which one sees in *Christ at Emmaus*, or in the *Jewish bride* or in those figures of strange angels. . . . That distressed tenderness, that superhuman gaping infinite which seems so natural, one finds it often in Shakespeare.'

CHRIST AT EMMAUS
Detail 90

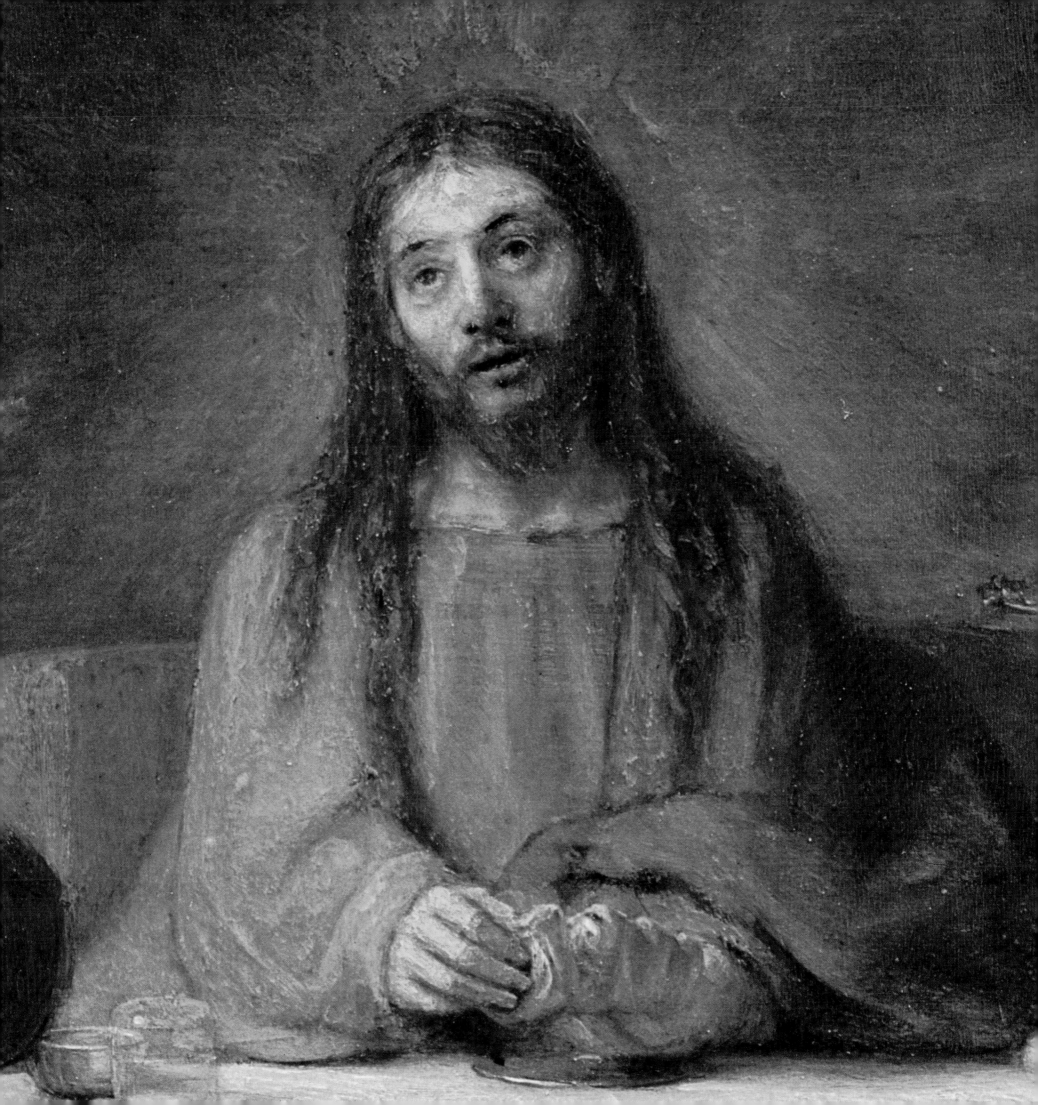

That of Susanna and the elders is a theme from the Old Testament often depicted by Rembrandt, particularly in his drawings. Among these, in the '30s, one finds a sepia and a pen drawing inspired by the painting executed by his master Pieter Lastman in 1614. An X-ray examination of this painting shows that the design has been altered many times; besides, the animated gesturing which characterized Lastman's work has disappeared. Rembrandt's interpretation of the subject is marked also by his use of monuments and landscape which are no longer anecdotal but are essential to the plastic structure of the composition. Finally, the link between Susanna and the elders is no longer intellectual and anonymous as in Lastman but sensual and individualized. The picture introduces the psychological novel.

SUSANNA SURPRISED BY THE ELDERS
1647: 76× 91 cm
Berlin-Dahlem, Gemäldegalerie 92

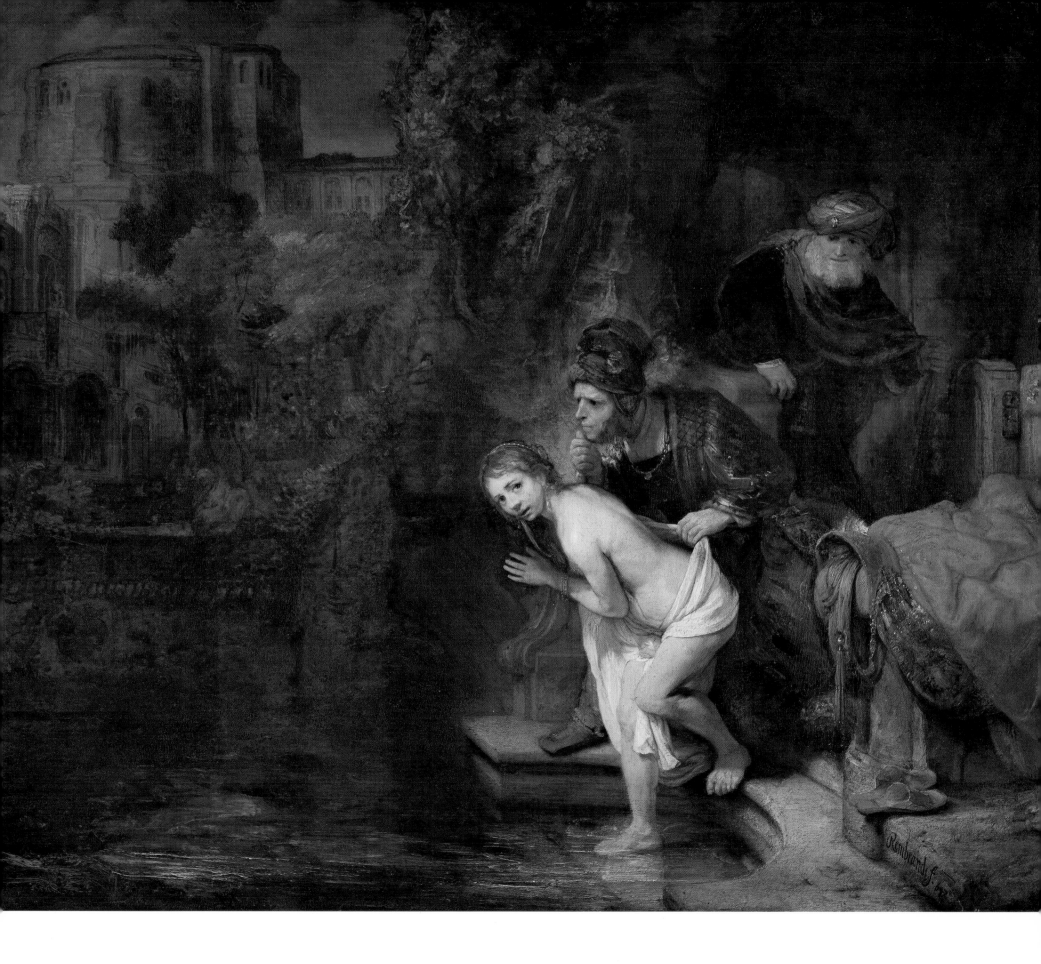

Like the Passion pictures, the *Adoration of the shepherds* (in the National Gallery since its foundation, together with the Angerstein collection) was painted for the Stadholder Frederick Henry. The London painting is a first version of the one given to the Stadholder and now in Munich. The series was exhibited in the prince's palace in The Hague. The difference in the use of light and movement between the first pictures, such as the *Entombment*, and those of 1646 is considerable.

The characters are no longer the center of the action: light groups them and unites them within the same joyous intimacy. In the twilight one can see the geometrical structure of the horizontal and vertical beams, and the curve of the ceiling which contains the curiosity of the shepherds within the limits of a serene wondering.

THE ADORATION OF THE SHEPHERDS
1646: 63 × 55 cm
London, National Gallery 94

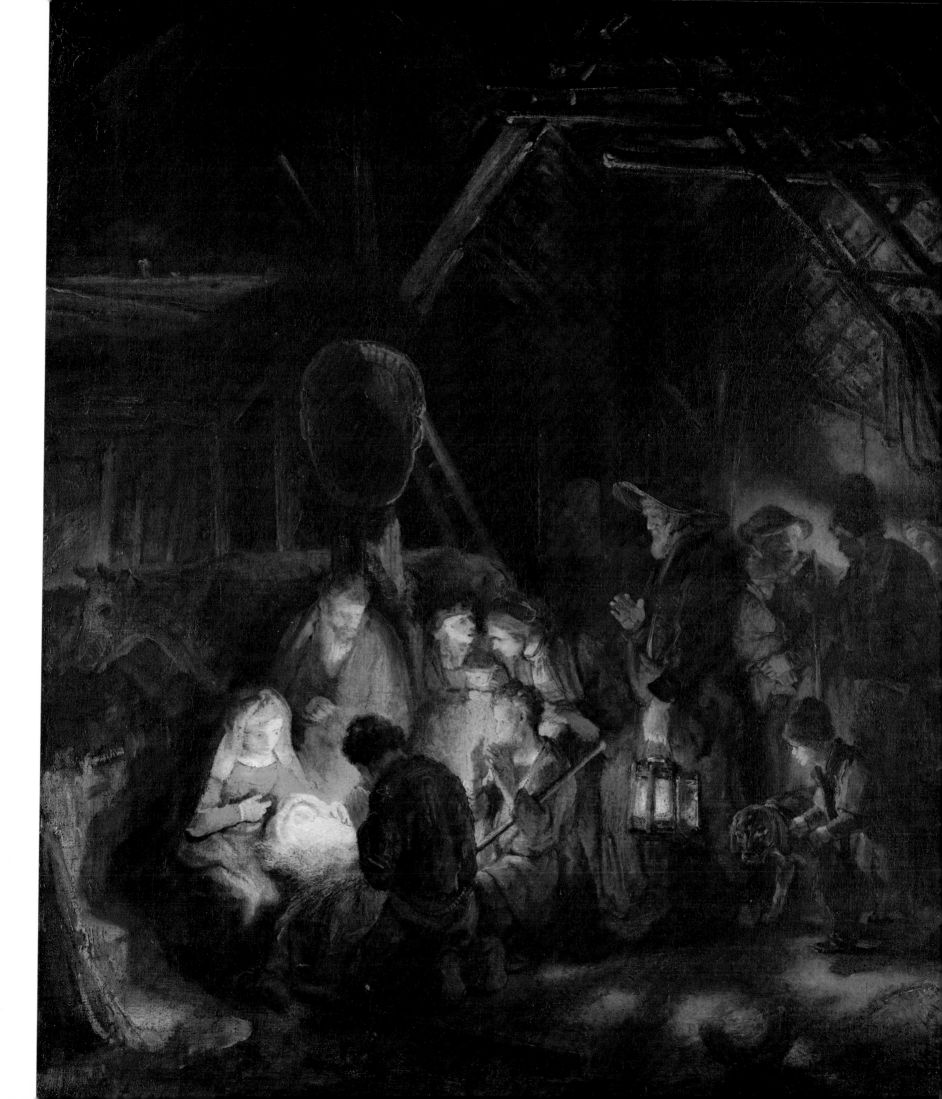

This little study is exceptional among Rembrandt's landscapes. It is close to the drawings and engravings of the same period in its realistic representation, in the precision and impulsiveness of its touches. In analyzing the tonalities and the intensity of cold air and winter light, Rembrandt manages to recreate a certain distance from everyday reality. He makes us feel the intimacy of a season which links the divestment of nature with the solitude of man.

WINTER LANDSCAPE
1646: 17× 23 cm
Kassel, Gemäldegalerie 96

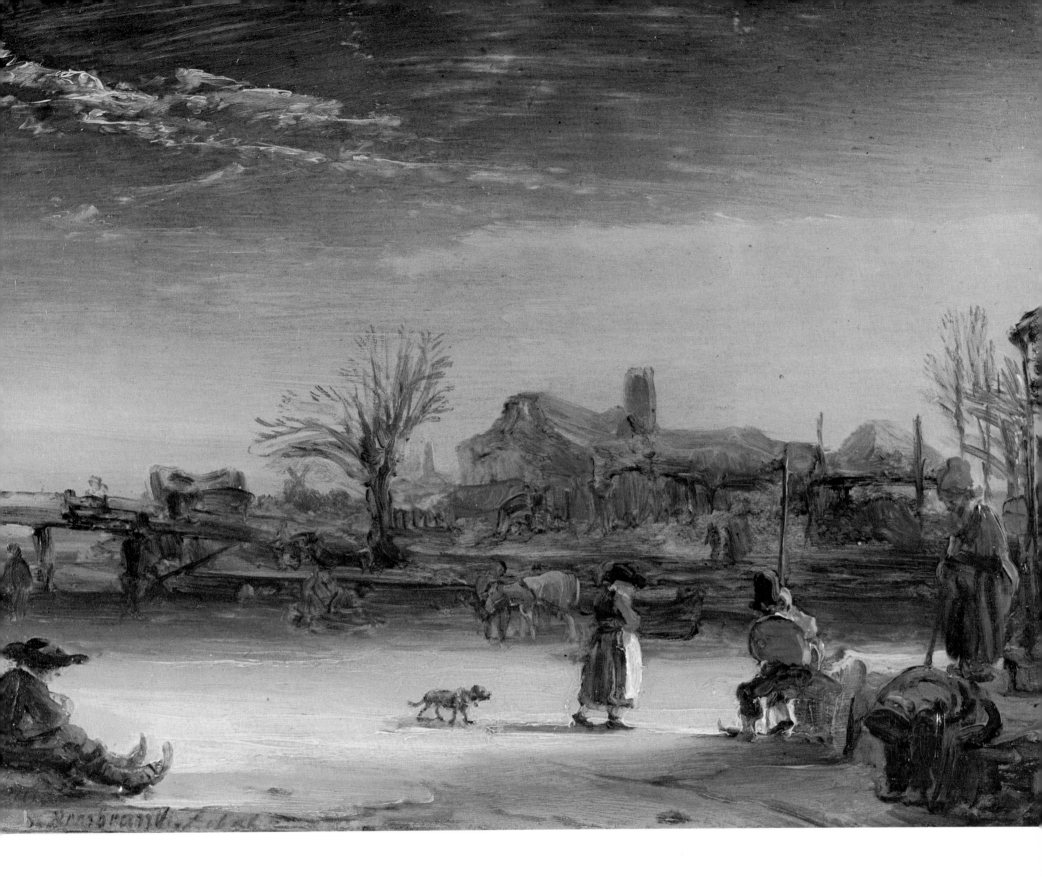

Rembrandt's nudes are always more than just nudes. In his first works, he uses them to question the classic canons of beauty; later, in his drawings, they achieve a lightness and freshness which remind one of Watteau or even Manet.

Hendrickje Stoffels posed for this picture; it contributed to her expulsion from her church by the Consistory who accused her of being the mistress of the painter. Bathsheba is holding the letter in which king David asked her to go and see him. She cannot refuse the king's invitation and she prepares herself for the meeting. The consequences will be tragic for Bathsheba's husband and her sons killed on David's orders. Bathsheba's sadness and melancholy contrast with the impatient curiosity of the adventuress Danae. . . . In his monumental presentation, his rich Venetian colors, the harmony of the forms which link in the same curve the mistress and the servant, Rembrandt draws from traditional classical painting, all the while imbuing it with the soul and carnal presence of a woman very close to us.

The composition has been likened to certain engravings by François Perrier showing antique bas-reliefs, published in Paris around 1645. But once again the sources are quite inadequate in explaining Rembrandt's personal vision.

BATHSHEBA WITH KING DAVID'S LETTER
1654: 142 × 142 cm
Paris, Louvre 98

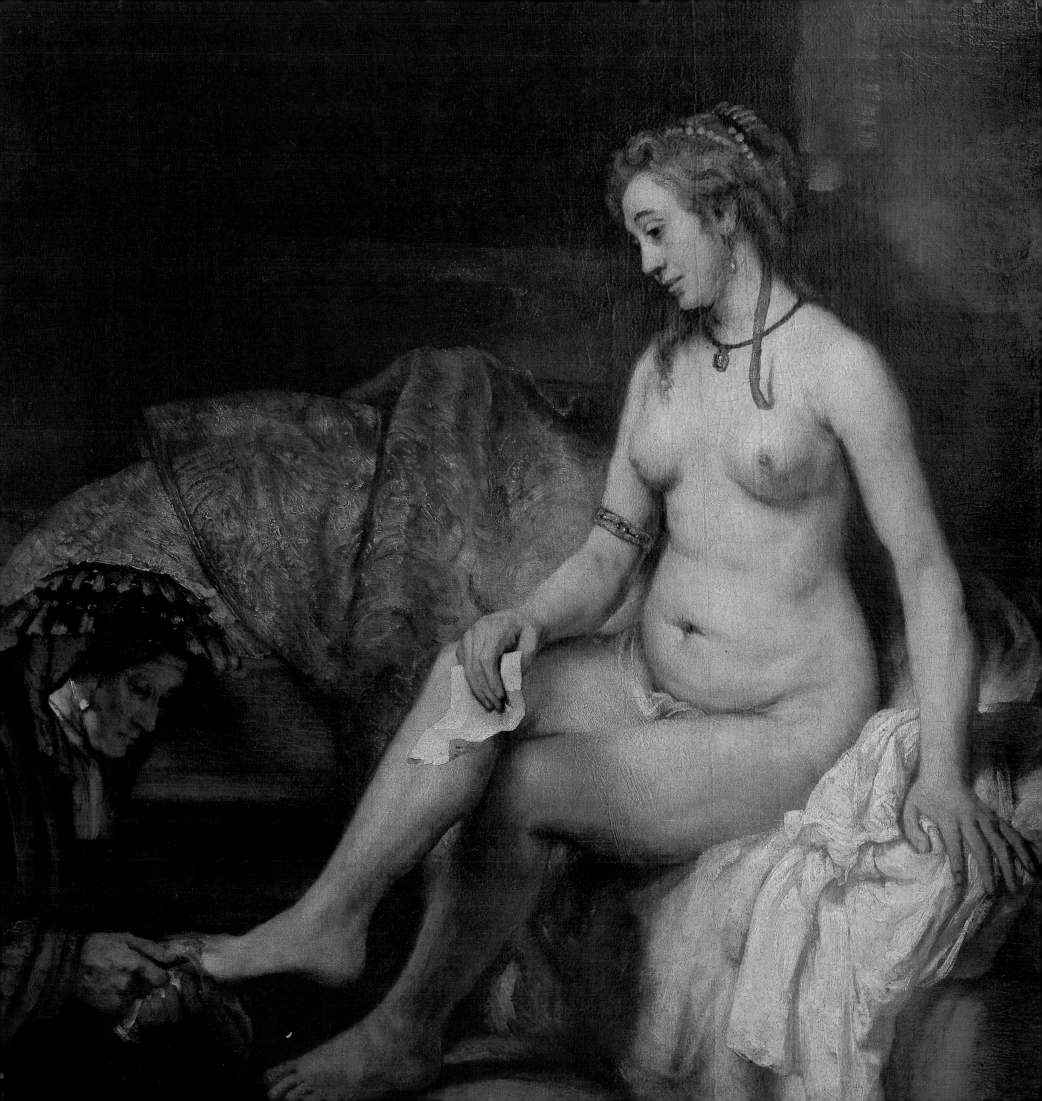

Titus was the only surviving child of Rembrandt and Saskia; in 1656 he was fifteen. *Titus at his desk*, of the previous year, is still the portrait of a child with all his serious simplicity and candor. In this portrait Rembrandt shows the oncoming of adolescence in Titus's posture, as he sits up straight and no longer leans on his desk, and in the intellectual concentration expressed by the eyes lowered on the book. The portraits of Titus recall that of the *Young girl at the window* of 1651. Their freshness and their intimate sweetness show a different aspect of Rembrandt's universe. Whereas the aged carry their visionary world in their eyes, the child or adolescent Titus opens his on the concrete world of Fragonard. It is the heroic paintings of this period which make one feel how much modern painting owes to Rembrandt's large and firm touch.

TITUS READING
1656: 70.5× 64 cm
Vienna, Kunsthistorisches Museum 100

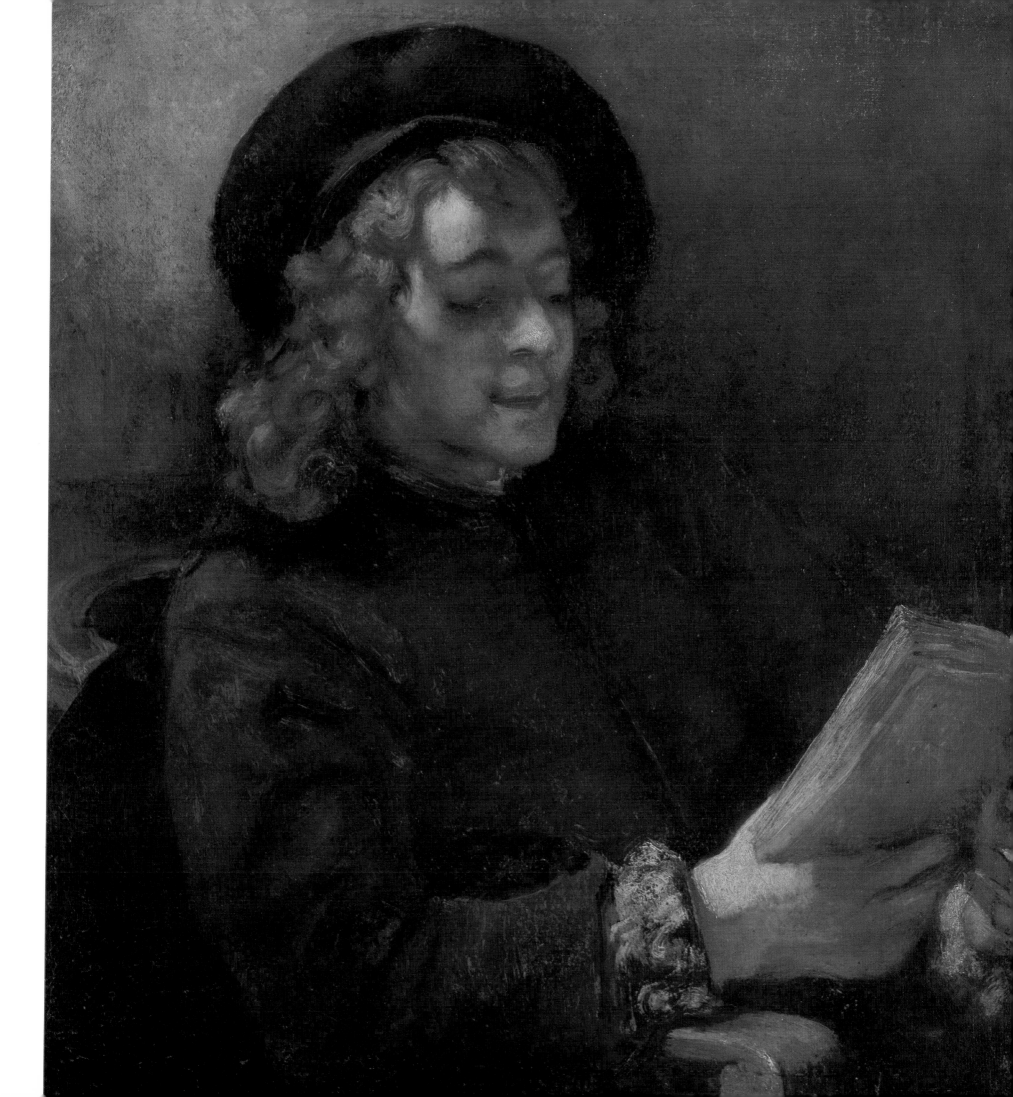

After the death of his wife Saskia in 1642, Rembrandt employed nannies to look after his son Titus; one of them was Hendrickje Stoffels. The painter made her his mistress, notwithstanding the slander amongst his circle. The portraits of Hendrickje differ from those of Saskia in their humanity which is contrasted to the ideal, romantic and bourgeois beauty of the latter. With Hendrickje we reach into Rembrandt's intimacy. Had the artist given way this far to follow the taste of his patrons or was his vision transformed by age? Both hypotheses are plausible, perhaps they even complement each other. His plastic values constantly evolved. Hendrickje is depicted in a monumental style which turns the drapery of the background into a multicolored architecture. The large and firmly applied brush-strokes confer plastic power to the modeling of the body. The way in which Hendrickje steps into the water shows a warm and blossoming woman: Rembrandt thus creates the northern version of the 'woman bathing'.

HENDRICKJE BATHING
1654: 62 × 47 cm
London, National Gallery 102

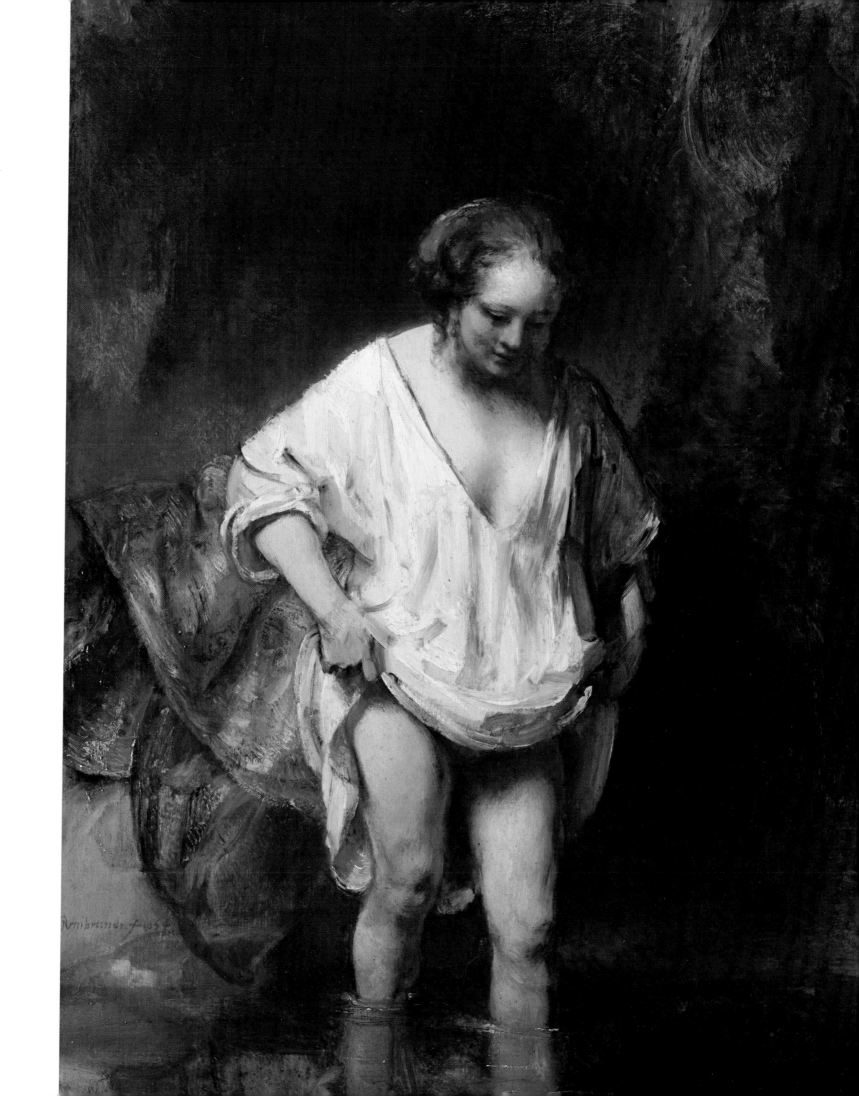

In the 1630s Rembrandt did not paint landscapes from nature. Only later, and mainly for his drawings, did he leave his studio to render in paint the plains of Holland. Jakob Rosenberg attributed the visionary quality of the light in Rembrandt's landscapes to the fact that he worked from dusk to dawn. The clarity of dawn outlined on the background of night is at the roots of the fantastic and fairy-like atmosphere of his creations. In this landscape one can distinguish the various sources, both Dutch and Italian, of his compositions together with that particular wish to individualize things and beings.

LANDSCAPE WITH AN OBELISK
1638: 55 × 71.5 cm
Boston, Isabella Stewart Gardner Museum 104

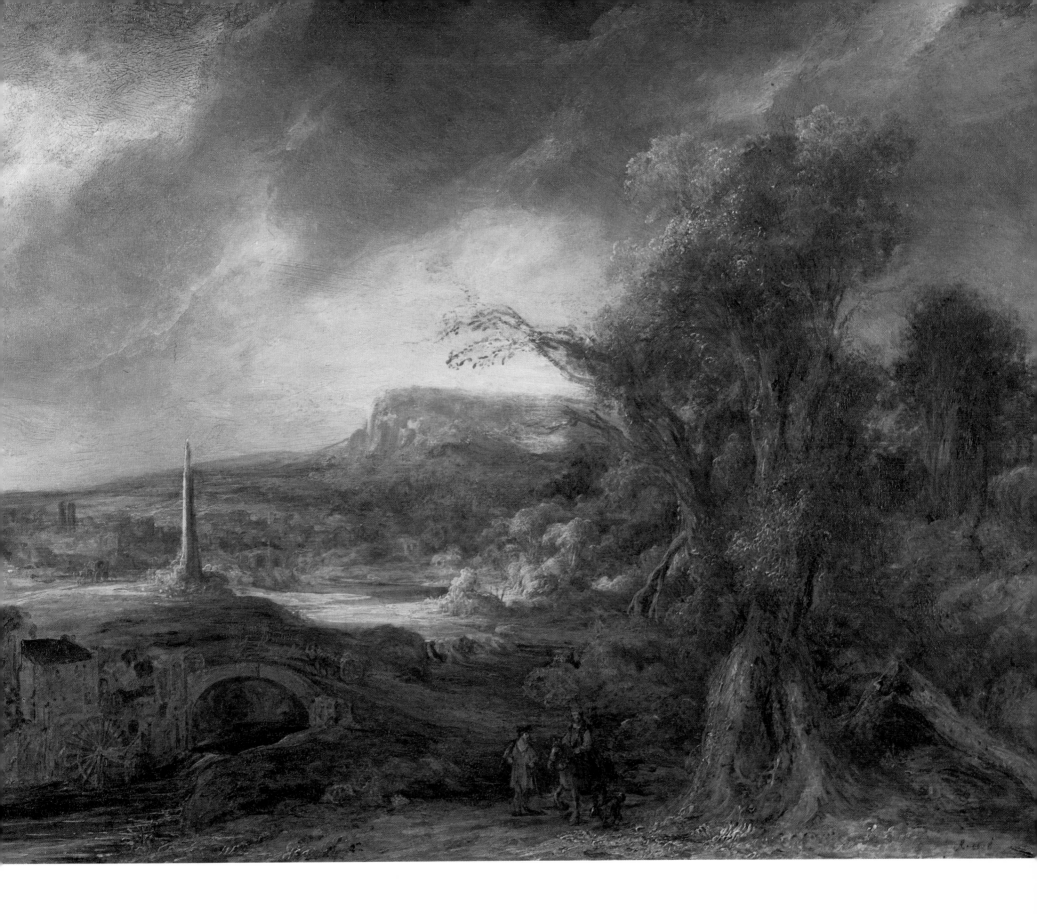

This portrait of Hendrickje (acquired by the Louvre in 1784, the same year as the *Portrait of Hélène Fourment* by Rubens) is one of the most pure and unencumbered of the whole of Rembrandt's oeuvre. The infinite depth of the glance it casts on the world links it with the self-portraits of the same period. Rembrandt has married the large touches of the coat with the delicate transparency of the corset and the diaphanous strokes of the face. The noble way in which she holds her head, the unity of tone and technique make Rembrandt equal to the great Italian portrait painters of the Renaissance. The composition is remarkable: the jewels are drops of light, the ovals of which answer in reverse that of the face of Hendrickje.

HENDRICKJE STOFFELS
1654: 72 × 60 cm
Paris, Louvre 106

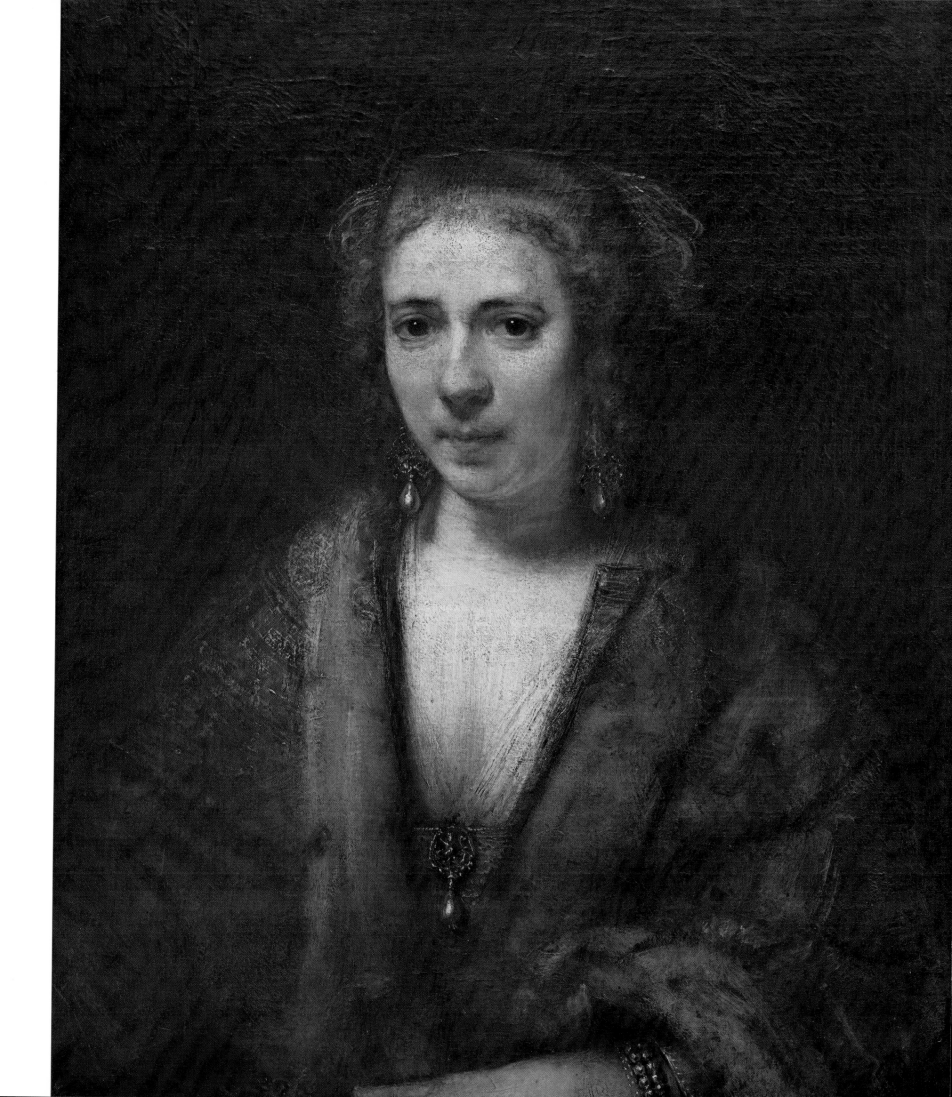

Alongside the heroic and monumental vein, Rembrandt continues to develop his intimate scenes, at once familiar and religious. According to H. Gerson, in this picture the delicate and moderate touch, the soft gradation of the light which bathes the people and the beams, the subtle alternation of areas of shadow and clarity, all this reflects the influence of Persian and Indian miniatures. Rembrandt had copied some of them in his sketch books and his etchings.

To show characters in profile, clearly delineated against the background, is also part of the tradition of Oriental miniatures. This device Rembrandt used to stress the unreality of this meeting between man and the gods.

The friendliness and the intensity of the action are expressed by the concentration of the protagonists and by the luminous environment, without their personalities being effaced. These warm tones of golden light and these ochres and browns were much appreciated by Rembrandt's pupils, even more than the monumental geometry of his heroic compositions.

JUPITER AND MERCURY VISITING PHILEMON AND BAUCIS
1658: 54.5 × 68.5 cm
Washington, National Gallery of Art 108

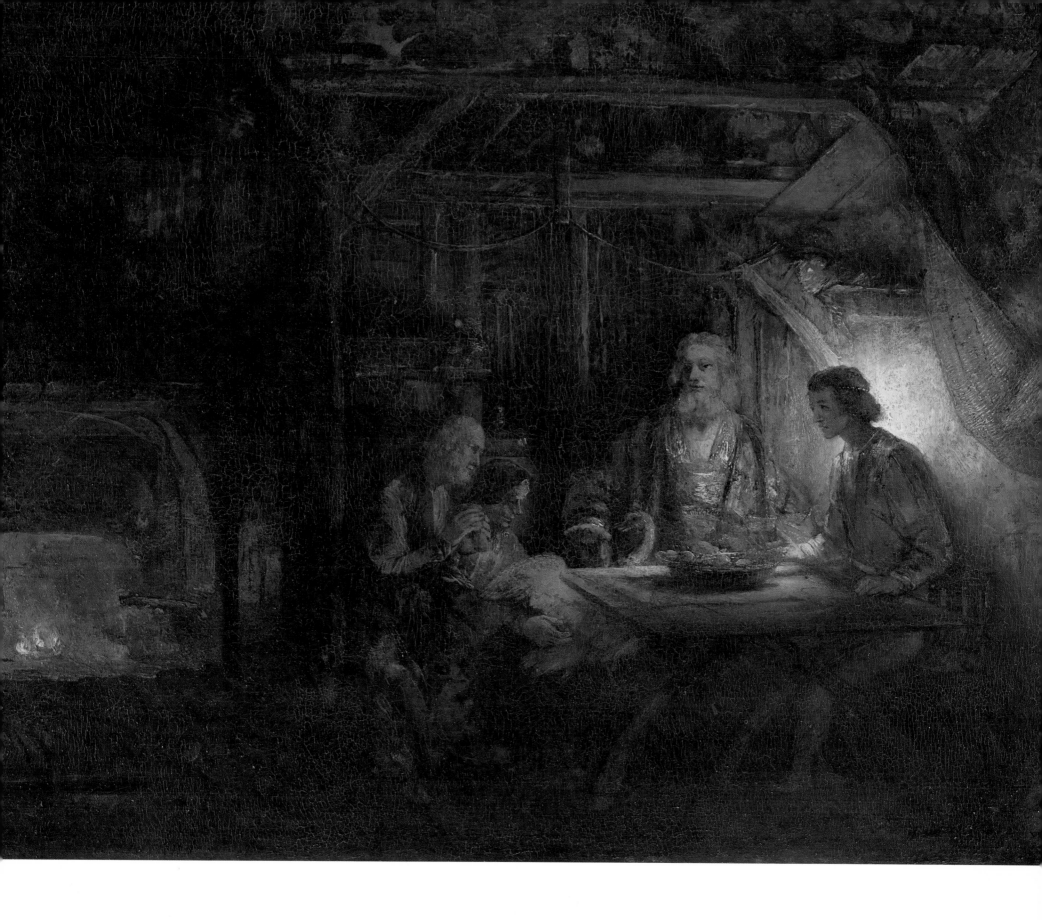

At the beginning of the 1660s Rembrandt painted a series of saints, apostles and evangelists. This self-portrait is part of the group, as he used to take himself as a model for his historical pictures: thus, a bit like an actor, he could put himself in the shoes of his characters and instil into them greater realism and life. One could however ask oneself whether the identification with St. Paul (thoroughly changed by, and a martyr of, the faith) is not somewhat deeper and whether the two symbols of Paul, the book and the sword, do not also symbolize Rembrandt's concern with the spiritual and the temporal worlds.

SELF-PORTRAIT
1661: 91 × 77 cm
Amsterdam, Rijksmuseum 110

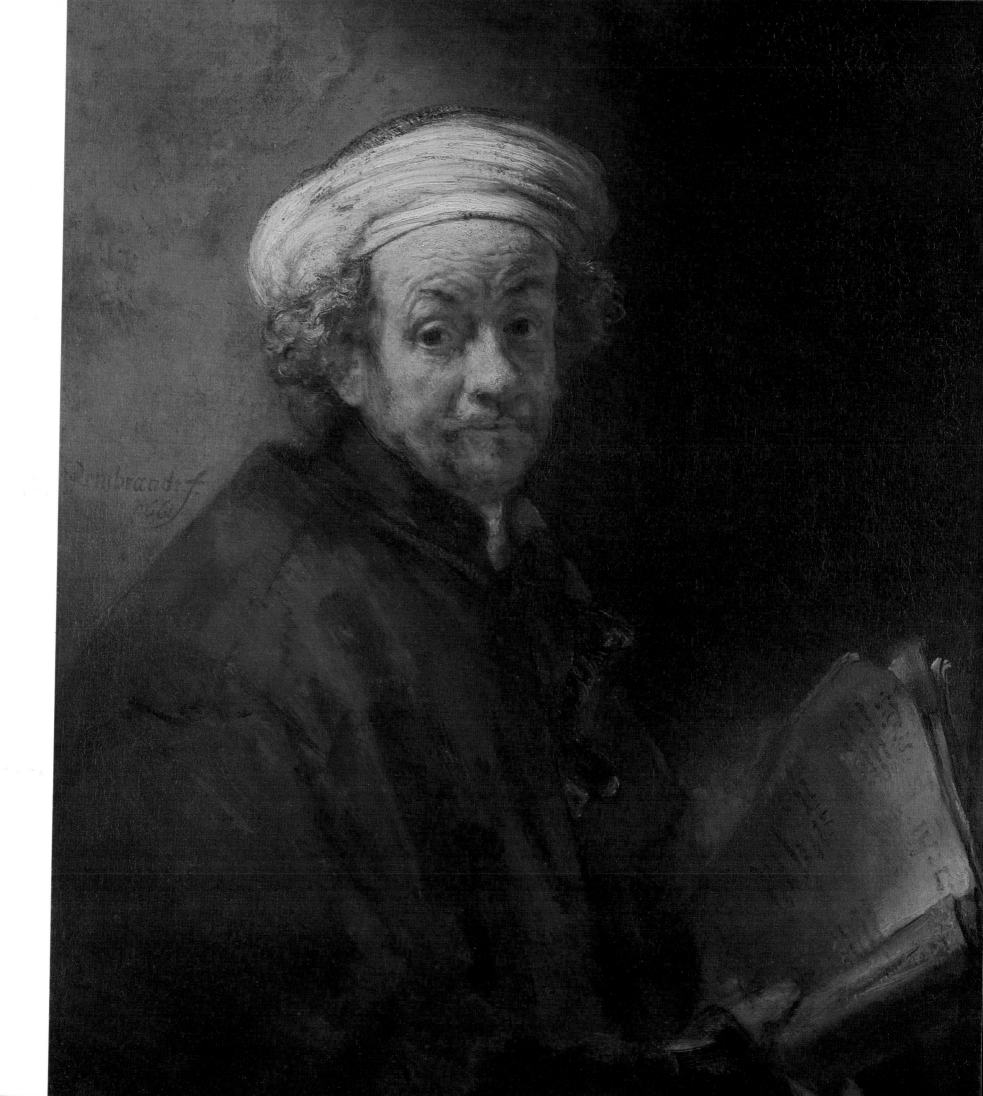

The circumcision of Christ belongs, with its sense of family event, among those intimate scenes of which *Philemon and Baucis* was a pagan example. Here Rembrandt's pictorial development results in more importance being given to the characters in relation to the construction of pictorial space. There is no cottage, no stable, only a tent-like drape. The secondary characters are no longer organized in groups around the main scene, as was the case in *The adoration of the shepherds*, but tend almost to leave the picture.

And look at the light: it is no longer diffused over the whole, it concentrates on the main characters, gathered round the child Jesus. Rembrandt here neglects the surroundings in favour of the psychological study of his characters.

THE CIRCUMCISION OF CHRIST
1661: 56.5 × 75 cm
Washington, National Gallery of Art 112

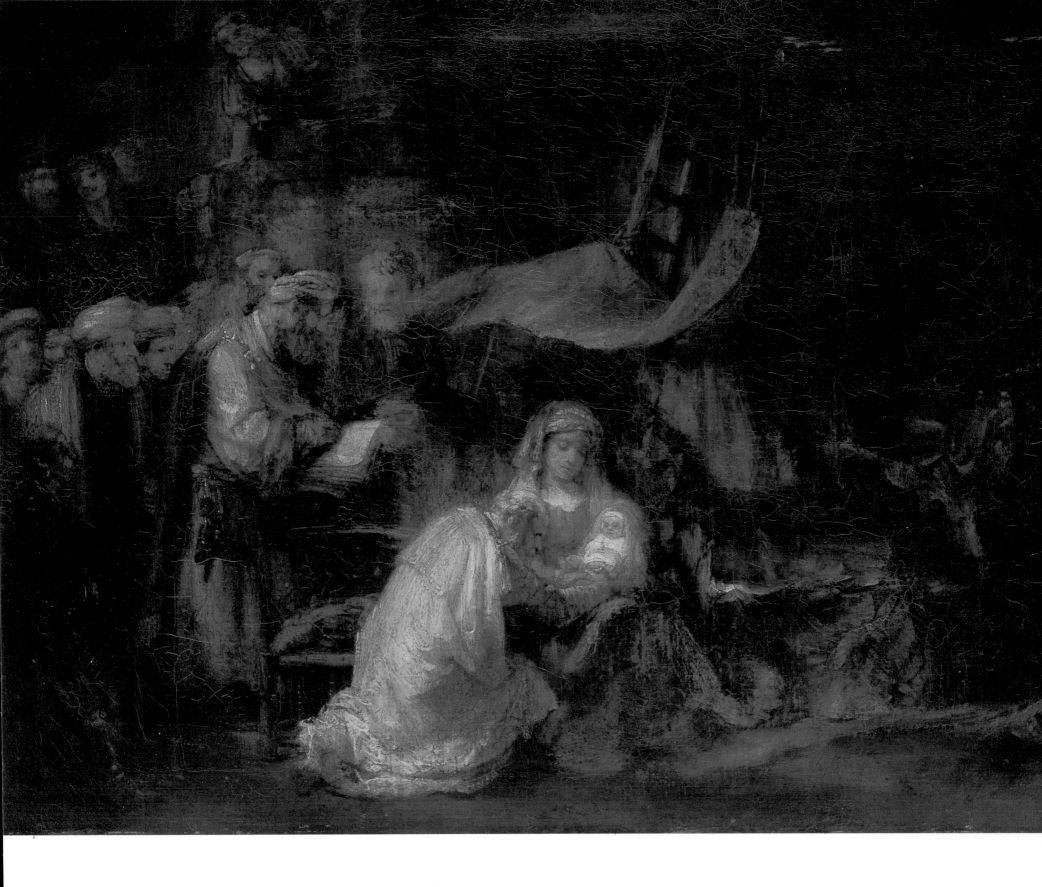

In his last landscapes Rembrandt retains the romantic imaginary details in the Italian style. A symbol of the world's fragility and apex of man's search, the cathedral in this landscape stands out against the horizon from which emanate the golden glimmers of spiritual light.

The artist's style is even more monumental than in his previous landscapes, his tones are warmer and the chiaroscuro is sprinkled with golden dust.

Rembrandt's landscapes are made of mystery and revelation, drama and serenity, of an heroic vein and pastoral feeling. Our eyes follow the composition from the barge to the bridge, from the bridge to the church and finally the sky.

RIVER LANDSCAPE WITH RUINS
1650: 67 × 87.5 cm
Kassel, Gemäldegalerie 114

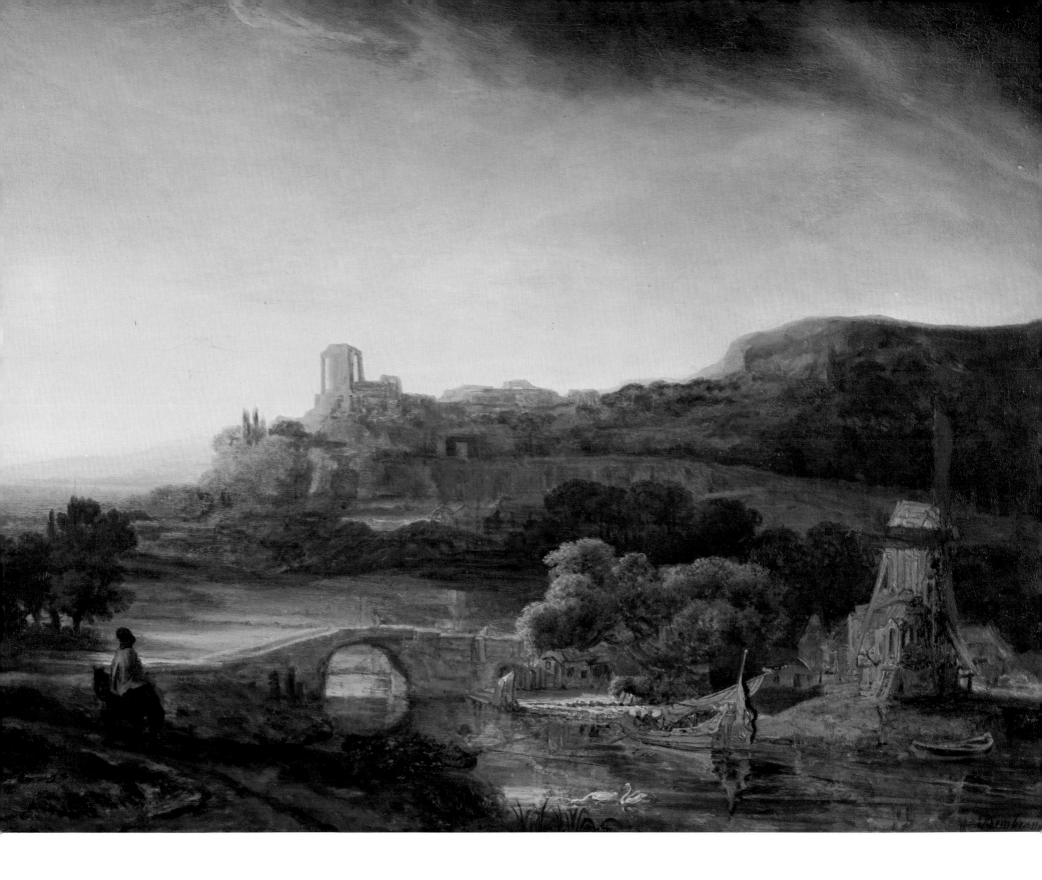

This St. Matthew is one of Rembrandt's most attractive pictures. According to the pictorial tradition the angel represents divine inspiration; it is an attribute of the Saint and that is why he does not turn towards it. And yet the link between the two characters is much stronger than would be warranted by a simple iconographic motif. The angel speaks to the heart of the Saint and emanates the light which illuminates him. There is a definite movement towards each other between the hand of the man and that of the angel. One is reminded that Titus was the model for the angel and that father and son were very close.

Rembrandt has achieved here, as he will in his last pictures, the union between the expressive power of the Italian painters of the High Renaissance and the tenderness of those of the Quattrocento. The wrinkles on the face and hand of St. Matthew are almost sculpted and the large, architectural features engage our eye, while the light silvery dust on the beard and the golden highlights on the angel's hair transform the chiaroscuro into a subtle variation of light on color.

'Thus Rembrandt painted the angels. He portrayed himself, old, wrinkled, with a cotton cap, a portrait from nature. He dreams and dreams, and his brush starts on his own portrait again but the face and expression become more distressed and distressing. He goes on dreaming, why and how I do not know but, as Socrates and Mohammed had a familiar genie, so Rembrandt paints a supernatural angel with a Leonardo smile behind this old man who looks like himself.' (Van Gogh.)

THE EVANGELIST MATTHEW INSPIRED BY THE ANGEL
1661: 96 × 81 cm
Paris, Louvre 116

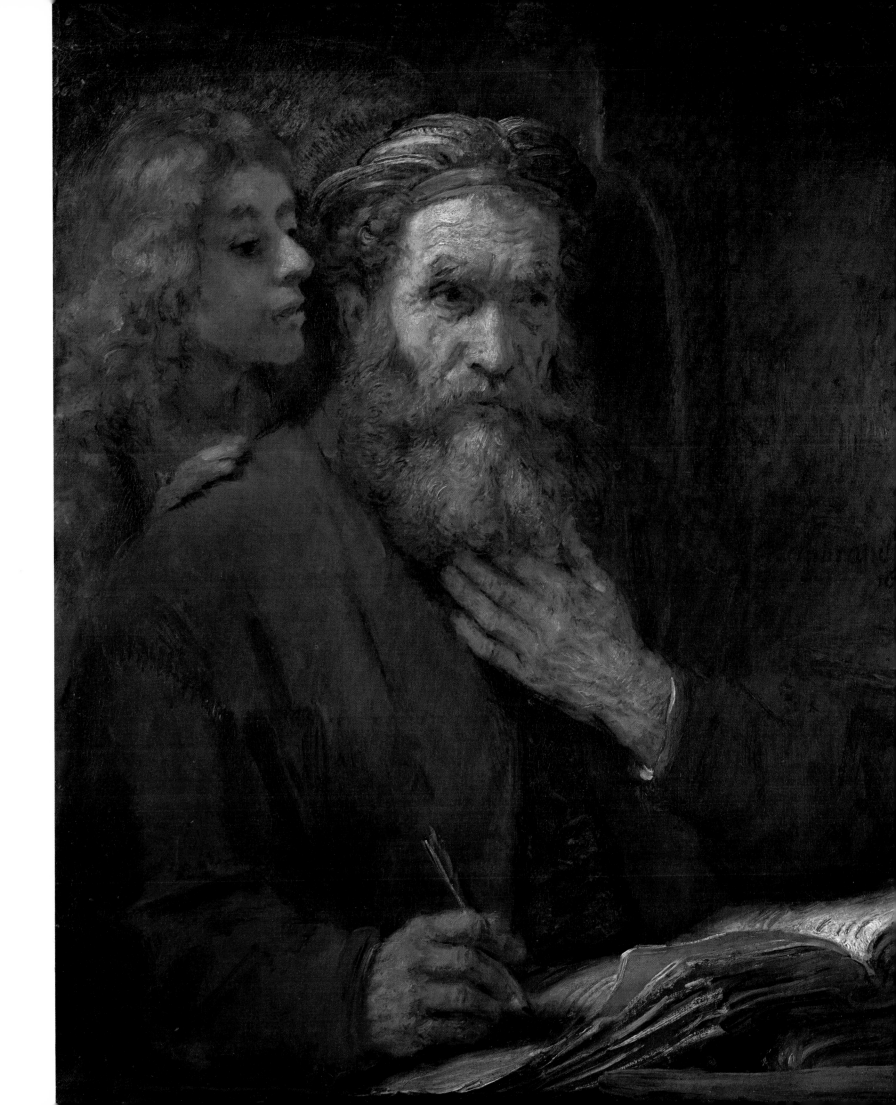

On the occasion of the building of the new Town Hall of Amsterdam, the municipal officials asked Govaert Flinck to decorate the great gallery. Flinck however died in 1660, and other painters, including Rembrandt, were called in. The general theme of the work was the historical struggle of the Dutch people to rid themselves of the Roman rule under the leadership of Julius Civilis.

Rembrandt chose to depict the banquet during which Julius Civilis, head of the Batavian revolt, asked for the sworn allegiance of the noblemen in the struggle against the Roman invaders. The authorities wanted to symbolize thus the recent war against Spain and expected a picture full of nobility and serenity. Rembrandt, on the contrary, went back to the story as told by Tacitus (*Histories*, IV, 14) and showed all the violence and excitement of men incited by wine and the words of their leader. The picture was sent back and replaced with one painted by Jurriaen Ovens. The original canvas was five meters by five, the largest Rembrandt ever painted. Unfortunately, in order to be able to sell it more easily, he cropped it and retained only the scene of the banquet. Thanks to a sketch, one can realize the monumental importance the banquet had, being reached via staircases and held beneath a vast vault. Undoubtedly Rembrandt retouched the picture so that it would not look like a fragment. The picture was intended to be hung high up on a wall in order to dominate the viewer. Whatever the state in which it reached us, it has not lost anything of its monumental power: Rembrandt's art used other means than the traditional Baroque and architecture in order to convey the heroic aspect of his characters. He actually created a new conception of monumental art by omitting the warm and neutral tonalities in favor of brilliant colors, like the red and the gold mixed with blue-grey and applied with a wide but light touch.

The mythical and barbarian grandeur of his characters has been compared with that of Shakespeare in *Macbeth* and *King Lear*. Today, after Fauvism, Expressionism and Rouault, we are more prepared to accept *The oath* among contemporary masterpieces than were the officials who refused it. 118

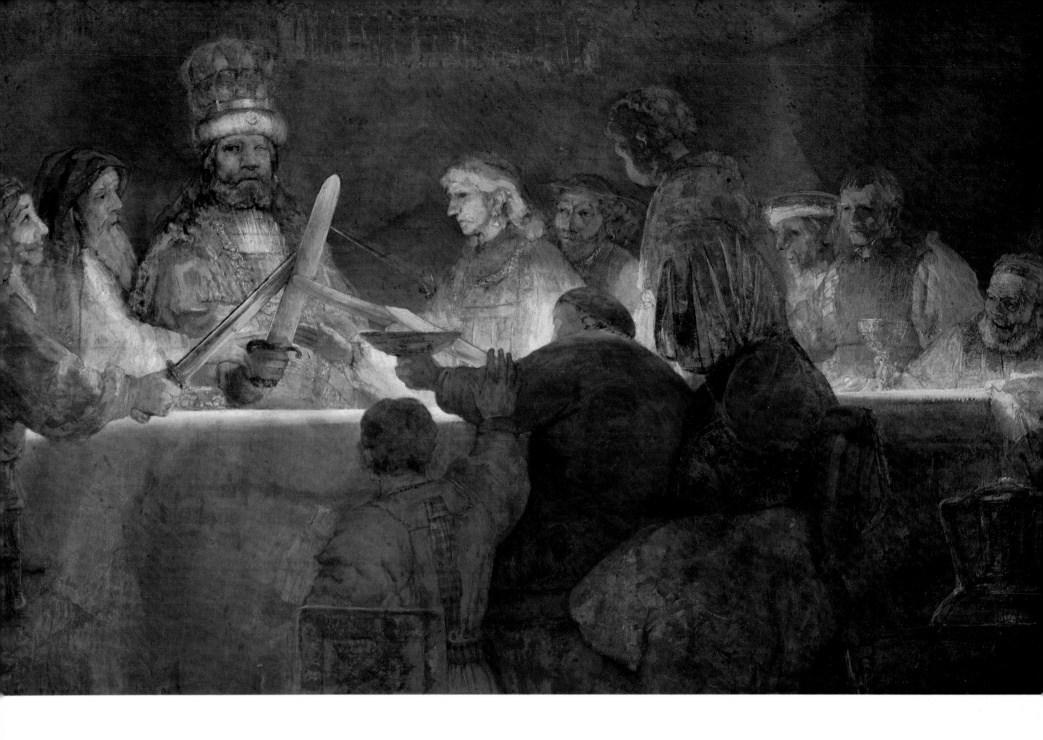

The *Two negroes* has always constituted a mystery. This picture, the composition of which reminds one of St. Matthew and the angel, cannot be explained by a religious theme, at least not at the present stage of iconographical research. Whether or not it is the double study of the same model does not explain the reasons which led the artist to paint such a picture. It represents probably both a concession to primitive christianity, which fascinated Rembrandt, and the pleasure of tackling pictorial difficulties. The *Two negroes* is the culmination of the relationship between the rendering of divine light and the use of monochromatic tones.

TWO NEGROES
1661 : 77.8× 64.4 cm
The Hague, Mauritshuis 120

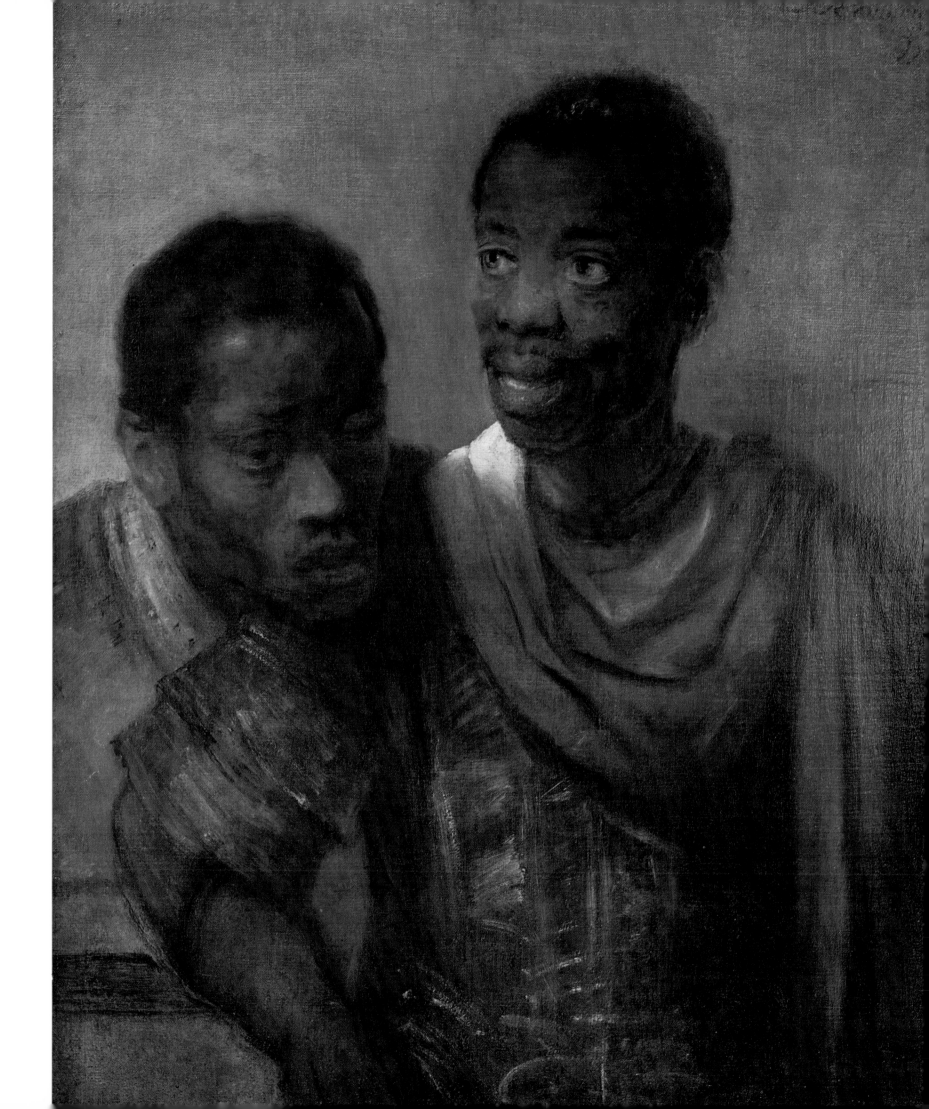

A greater sobriety of tones and the absence of props such as a desk or table differentiate this portrait from *Titus at his desk* and *Titus reading*. As in the self-portraits of the same period, Rembrandt knows by now how to express the nobility of a face without the help of external expedients. The sense of unreality of his characters is due to the amazing relationship between a pictorial representation in advance of his own time and a still ancient narrative context which, in the absence of all detail, survives in the religious treatment of light.

PORTRAIT OF A YOUNG MAN (TITUS?)
1663: 81 × 65 cm
London, Dulwich College Gallery 122

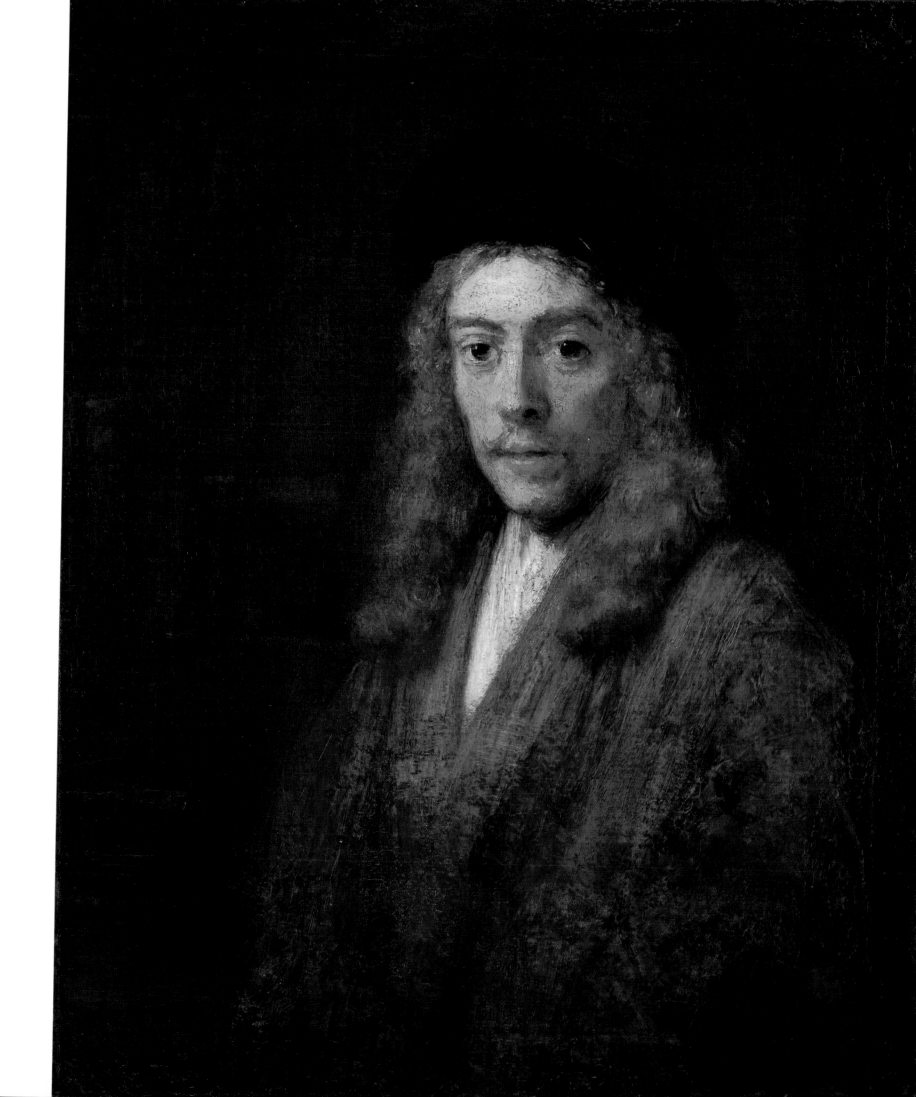

In 1643 Rembrandt had already been executing for a few years his lovely drawings of landscapes from nature. His pictures, however, remain entirely imaginary. The development from the first fantastic landscapes (*Stormy landscape with the good Samaritan*) to those of the '40s must be related to the more general change which took place in his historical paintings.

Thus this landscape can be likened to the monument appearing in the background of the *Reconciliation of David and Absalom*. Romantic and baroque buildings aid the plastic construction of a picture. The first impression produced by the relationship between the monochromatic browns of the foreground and the luminosity of the sky is of a barrier of mineral and vegetable forms, in the style of Max Ernst: but if one allows one's eye to penetrate into the picture one discovers a bridge, a river, some trees.

LANDSCAPE WITH A CASTLE
1643: 44.5 × 70 cm
Paris, Louvre 124

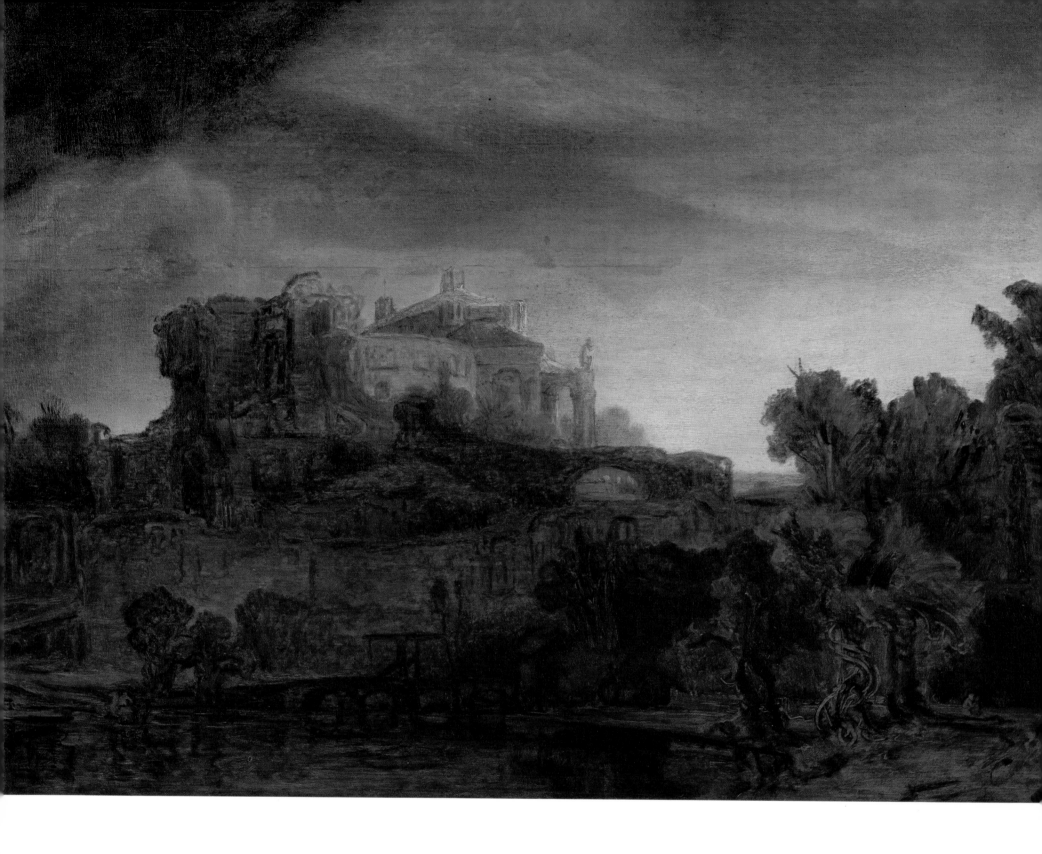

The sculpture which appears in the top left hand corner of the picture was at first identified as Heraclitus, the philosopher who mourns the miseries of the world, while Rembrandt himself would represent Democritus, the philosopher who laughs at the world's miseries. A recent X-ray examination of the picture, showing that originally Rembrandt's hand touched the bust, has rendered void this dualistic interpretation. The self-portrait was then likened to *Aristotle contemplating the bust of Homer* (1653) in which Aristotle lays his hand on Homer's head. More recently Bialostocki has identified in the sculpture the god Term who represents the end of everything, death, while Rembrandt depicts himself as a contrast with a smile as if to say 'Concedo nulli' . . . I give in to nobody.

SELF-PORTRAIT
1665: 82.5 × 65 cm
Cologne, Wallraf-Richartz Museum 126

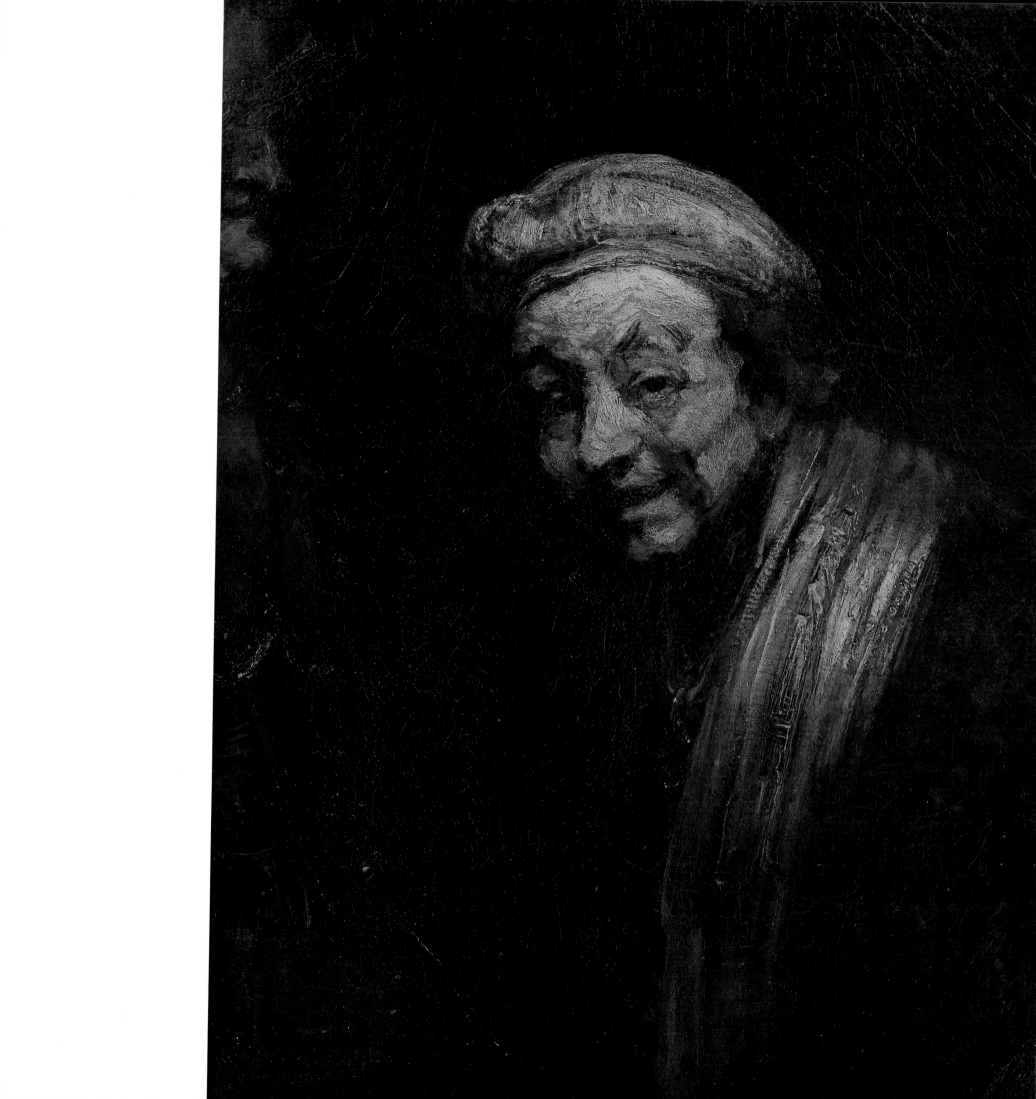

'Rembrandt was the first painter' said Horst Gerson, 'who could evoke on the flat surface of a canvas the deep emotion of an embrace.' This is what posterity remembers about this painting, unable to substitute the names of Isaac and Rebecca to the title of *The Jewish bride*, so much more familiar.

This picture has been the object of various conjectures: is it a Biblical or historical subject? Are the models the artist's contemporaries, don Miguel de Barrios and his wife Abigael de Pina, or Titus and his fiancé? If Rembrandt has suppressed the anecdotal element of Abimelech peeping in on the courtship of Isaac and Rebecca, we have no reason to put it back into the picture. The gesture of the lovers of Amsterdam is beyond interpretation and if part of the composition is inspired by others in Venice, as the style is inspired by Giorgione, the mystical fervor of Rembrandt is certainly not missing.

To his contemporaries, Rembrandt was the painter of chiaroscuro and neutral tones. Here in the treatment of color he is on the same level as Velasquez or Rubens. 'The Jewish bride, a history of the love born by the yellow and gold for the red mixed with ochre' said Claude Roy. Rembrandt's work is veined by flashes of color like in the *Night watch* or *Danae*; but more often color melts into light, or is attributed by the critics to his interest for Oriental costumes and his taste for the unusual. Here color transfigures the clothes while the hand and the eyes of the bride meet those of her lover in a world which is not the one we know but rather that of Rembrandt.

THE JEWISH BRIDE
1665: 121.5 × 166.5 cm
Amsterdam, Rijksmuseum 128

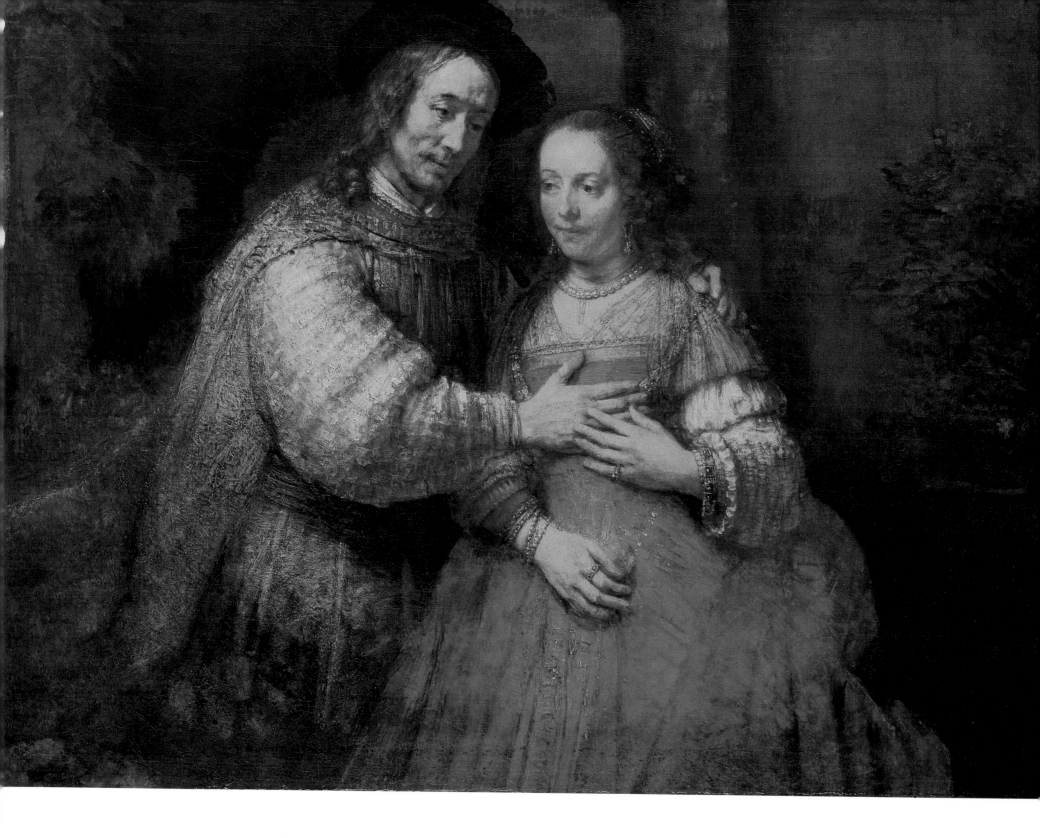

'To choose instead the faces, like Rembrandt, for whom the first landscape of the world is somebody's appearance, and those living surfaces onto which death leaves his mark to turn them into old men and soon into newly-born ones.' (Claude Roy.) The last of Rembrandt's pictures was left unfinished on his easel. The relationship between the old man and the child, death and life, is at the center of his work. The delicacy of his strokes, which here is related to Oriental art, and the liquid light confer onto this final scene its visionary and extra-temporal character.

SIMEON AND THE CHRIST CHILD IN THE TEMPLE
1669: 98 × 79 cm
Stockholm, Nationalmuseum 130

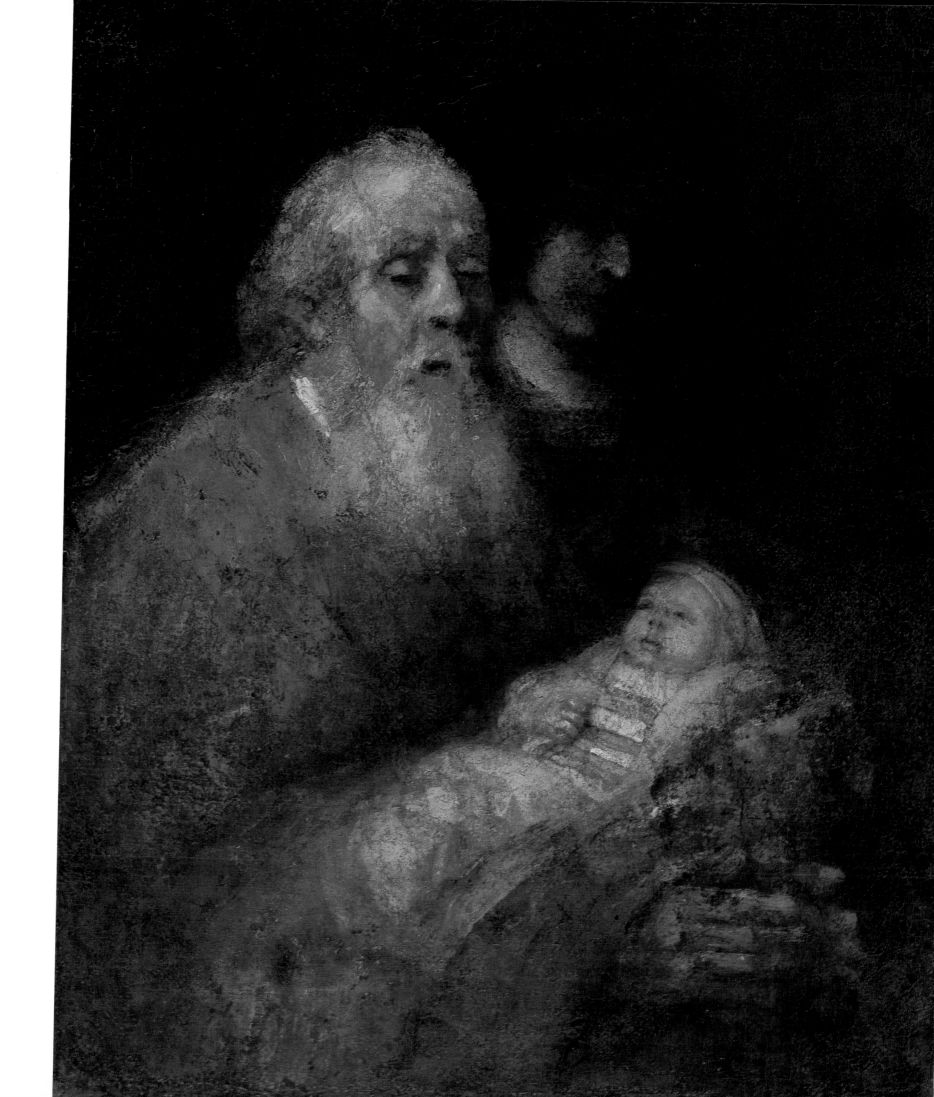

The last portrait executed by Rembrandt shows that he could depict himself as he was. The last homage to the mirror of a man who had spent his life on the other side of a mirror, interpreting the lesson of the latter as he had that of his teachers; and who could use the lightest brush to paint a face worn by time and a delicate and diaphanous flesh which dies because it has lived.

SELF-PORTRAIT
1669: 59 × 51 cm
The Hague, Mauritshuis 132

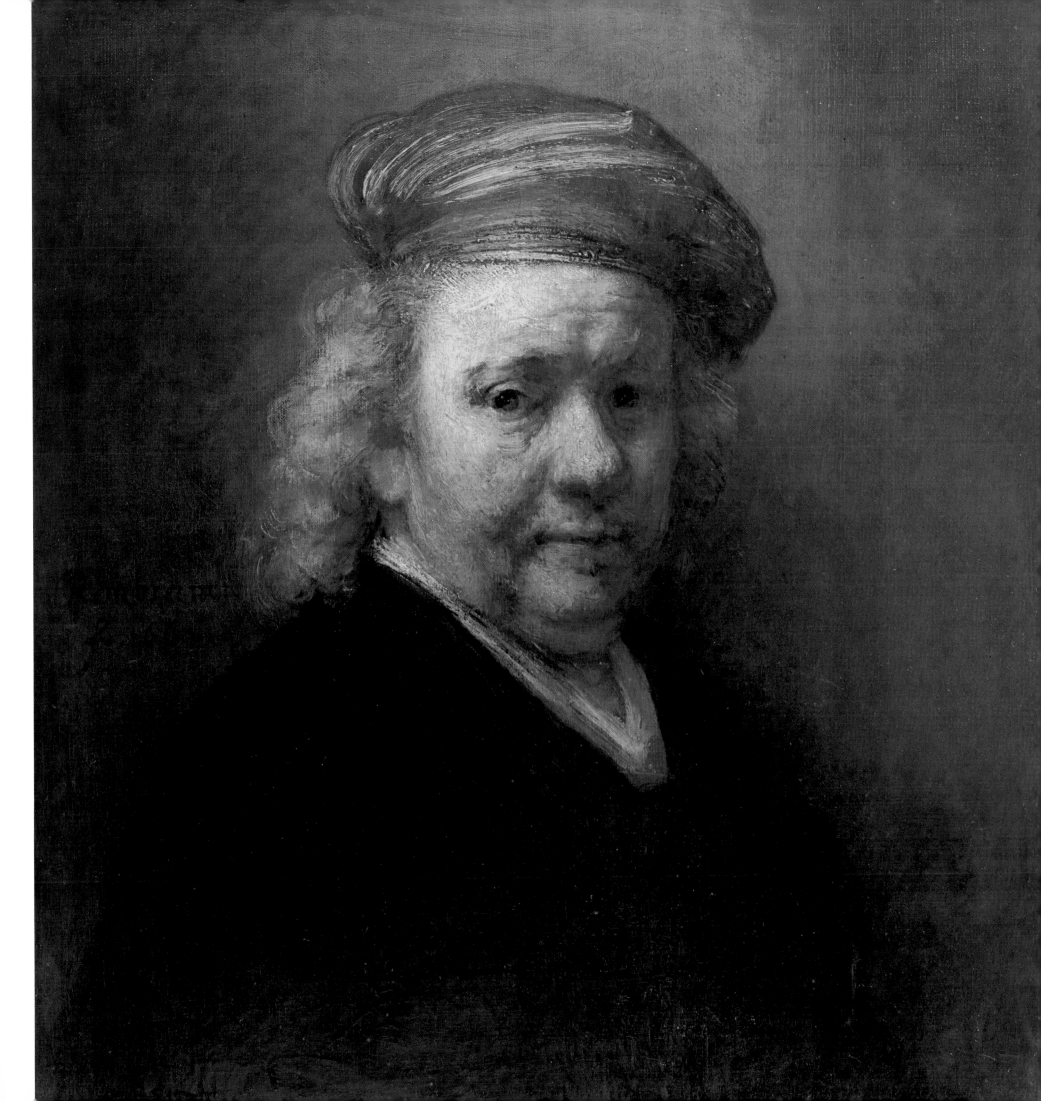

Chronological Notes ·

1600-04

The war between Holland and Spain has been going on for thirty years. Velasquez and Claude Lorrain are born. Shakespeare, in full maturity, writes *Hamlet* (1600) and *Othello* (1604).

1606-10

Rembrandt is born in Leyden. His father is a carpenter, his mother the daughter of a baker. Corneille is born in 1606; Poussin is 14, Georges de la Tour 15, Rubens 30. Monteverdi, at the age of 40 (1607) writes *Orfeo*, the first lyrical drama. El Greco, at 67 (1607) and six years before his death, paints the *View of Toledo* and the *Laocoon* both showing his visionary and mystical temperament and the modernity of his technique. The truce with Spain (1609) marks the beginning of the independence of the Northern Low Countries (Holland). Henry IV of France is murdered (1610) and his son Louis XIII is only 9; Maria dei Medici is elected Regent.

THE YEARS OF LEYDEN 1606-1632

1620-26

Rembrandt is registered as a student at the University; he spends very little time there, even assuming he did join. 'His parents had sent him to the School' wrote Jean Orlers, burgomaster of Leyden, 'so that he might learn latin and might then join the Academy, in order that, when of age, his knowledge might be of use to the Town and the Community, but he had no inclination for these studies, as his natural tendencies were all towards the art of painting and drawing. That is why they were obliged to withdraw their son from the School and send him to a painter so that he might learn the foundations and principles of this art. . . . Therefore they took him to the excellent painter Jacob van Swanenburgh; the

135

boy remained with him about three years during which time he made such progress that connoisseurs were astonished and it was obvious he would become, in time, an excellent painter.'

La Fontaine is born in 1621, Moliere in 1622, Pascal in 1623. The war between Spain and Holland starts again (1621).

Rembrandt moves to Amsterdam (1623) to complete his studies with the painter Pieter Lastman. But according to Orlers his stay is brief: 'After six months he decided to practice on his own as a painter.' He is 17. He returns to Leyden where he opens a studio which he soon shares with his friend Jean Lievens (1607-74). The poet Constantijn Huygens, on visiting their studio, expresses his surprise at the youth and certain genius of the two young men.

1629-31

Rembrandt paints the *Self-portrait* now in The Hague (p.64). He is 23: an adolescent head, 'full of health, spontaneity and grace. It exudes will-power, intelligence and a certain authoritative air which explains the influence this young man will have on his contemporaries.' (Emile Michel.) Constantijn Huygens, jurist and poet, mentions Rembrandt and Lievens in his journal and places them already 'on an equal footing with the most well-known painters.'

In 1630 Rembrandt's father dies. In 1631 he paints an admirable portrait of his mother (p.72), *A scholar in a lofty room* (p.66) and the 'philosopher' in the Louvre. A friend of Hendryck van Uylenburgh, picture merchant, he often stays in Amsterdam. His reputation increases and he obtains various commissions for portraits.

1632-34

Rembrandt, at 26, settles in Amsterdam with his friend Hendryck van Uylenburgh.

1632 is the year in which he attains fame. He is entertained by Jan Six, art 136

collector; he frequents the nobility; he is invited to paint, for the corporation of surgeons, *The anatomy lesson of Professor Tulp*. This is the breakthrough. 'One could only please the public by following his style' writes Houbraken. And yet, he adds, 'he lived very simply and while working he was happy with some cheese or herring on a piece of bread.' He paints (1634) *St. John the Baptist preaching*, now in Berlin.

Vermeer is born in Delft.

1634-37

Rembrandt opens a studio on the Bloemengracht and Joachim de Sandrart writes: 'His Amsterdam house was full of pupils and relatives, each one paying him up to 100 florins a year, without counting the money brought to him by their pictures and engravings, which, apart from his own earnings, can be valued at 2000 or 2500 florins.' He marries Saskia van Uylenburgh, niece of his friend, daughter of a rich upper class family. He is 28, she 18. He paints *The erection of the cross* and *The descent from the cross* (Munich), *Saskia as Flora* and the *Danae* of Leningrad.

Descartes publishes his *Methodology*; Poussin paints *The abduction of the Sabines*, Velasquez *The surrender of Breda*, Philippe de Champaigne the *Portrait of Richelieu*, Rubens *The adoration of the Magi*. France intervenes in the Thirty Years War.

1638-42

Rembrandt continues the little known series of the twelve landscapes, painted between 1636 and 1650: *Landscape with the baptism of the Eunuch* (1636, Hanover), *Landscape with a stone bridge* (1637, Amsterdam), *Stormy landscape with the good Samaritan* (1638, Cracow, p. 68), *Stormy landscape with an arched bridge* (1638, Berlin-Dahlen, p. 78), *Landscape with an obelisk* (1638, Boston, p. 104), *Landscape with ruins* (1639, private collection), *Stormy landscape* (1639, Brunswick, p. 86), *Landscape with a church* (1640, Madrid), *Landscape with a coach* (1641, London),

Landscape with a castle (1643, Paris, p. 124), *Winter landscape* (1646, Kassel, p. 96), *River landscape with ruins* (1650, Kassel, p. 114).

In 1639 Rembrandt buys a house in the 'Jooden' Breestraat, the Jewish quarter, for 13,000 florins payable in six years. His mother dies in 1640. Saskia dies a year after the birth of Titus (1641), the only one of her four children to survive. Racine is born in 1639 and Rubens dies in 1640. Monteverdi, called 'divino' by his century, composes, a year before his own death, the *Crowning of Poppea* (1642), forerunner of melodrama and modern opera.

Rembrandt paints *The reconciliation of David and Absalom* (1642, Leningrad, p. 74) and *The night watch* (1642, Amsterdam, p. 80). The lack of understanding with which this monumental picture is received marks a turning point in the artist's life.

1645-48

<p style="margin-left:2em">HENDRICKJE:
THE GLOOMY YEARS
1645-1669</p>

Rembrandt is 39; the young Hendrickje Stoffels becomes, at 19, first his servant then his mistress. She is a simple girl, 'a young peasant from Ransdorp in Waterland' (Houbraken). She can hardly write and signs her name with a cross. She often poses as Rembrandt's model: we find her in *Bathsheba* (Louvre, p. 98). He paints *Susanna surprised by the Elders* (1647, Berlin, p. 92) and *Christ at Emmaus* (1648, Paris, p. 88).

Spain recognizes the independence of the United Provinces (Treaty of Westphalia). Cromwell comes to power after the death of Charles I.

1649-56

Rembrandt is in financial difficulties. He has not yet finished paying for the house in the Breestraat, bought in 1639. Should one blame his collecting passion, his carelessness, or the situation of Holland, severely harmed in its economy by the war? The creditors become impatient. Rembrandt appeals to Jan Six and borrows from everywhere.

138

Hendrickje gives birth to a daughter. Rembrandt would like to marry her but cannot do so because of a clause in Saskia's will depriving him of his usufruct if he remarries. 'Rembrandt's mood becomes more and more gloomy. He withdraws from society, and his talent frees itself from the obligations of success. He seeks the company of learned men, theologians, rabbis, Portuguese intellectuals who live in his quarter.' (Claude Roger-Marx.)

He paints *Bathsheba* (1654, Paris, p. 98), the *Portrait of Jan Six* (1654), the *Slaughtered ox* (1655, Paris), *Hendrickje bathing* (1654, London, p. 102), *Titus reading* (1656, Vienna, p. 100).

1656-60

His creditors bankrupt him. His house in the Breestraat and all his goods are sold, but he still has not enough to repay all his creditors. He moves into an hotel, which he soon has to leave as he cannot pay. How can he work under these conditions? The last years are still those of his greatest masterpieces. He paints *Jacob blessing the children of Joseph* (1656, Kassel), the *Self-portrait* (1657) of Vienna, *Jupiter and Mercury visiting Philemon and Baucis* (1658, Washington, p. 108) and the *Feast of Esther* (1660, Leningrad).

Vermeer paints the *View of Delft* in which space, colors and light achieve a rare degree of precision and poetry.

Purcell is born in London (1659) and will become one of the greatest musical geniuses ever born in England. 'His harmonic audacities, dissonances and modulations, which arise from the simultaneous use of tonal and modal scales, from the sudden shifting between major and minor, make of him a great forerunner.' He realizes his dramatic ideal in *Dido and Aeneas* (1681), his masterpiece. Cromwell dies in England; Louis XIV marries Marie-Therese of Austria (1660).

1661-69

Hendrickje and Titus, in order to help Rembrandt in his misfortune, form a

society dealing in pictures. The artist is their employee and his salary is board and lodging. Thus he evades his creditors. The three together move to the Rozengracht. In this humble house Rembrandt, freed from his worries and surrounded by the affection of Hendrickje and Titus, paints the *Circumcision of Christ* (1661, Washington, p. 112), *The conspiracy of Julius Civilis* (1661, Stockholm, p. 118), *St. Matthew inspired by the angel* (1661, Paris, p. 116), a *Self-portrait* (1661, p. 110) and *Two negroes* (1661, p. 120) both in Amsterdam, the *Portrait of Titus* (1663, Dulwich, p. 122), *The Jewish bride* (1665, Amsterdam, p. 128), the *Self-portrait* in Cologne (1665, p. 126), *Simeon and the Christ child in the Temple* (1669, Stockholm, p. 130), the *Portrait of a family* (1668-9, Brunswick) and the moving *Self-portrait* of The Hague (1669, p. 132). Between the latter, at the end of this book, and the 1629 *Self-portrait* also in The Hague, which opens it, from triumphant youth to shattered age, lies the course of a whole life.

Hendrickje died in 1662 at 36, Titus in 1668 at 27, Rembrandt in 1669 at 63.

Chronology by Simon Monneret and Claude Roger-Marx.

Selected Bibliography

A. Bredius and H. Gerson, *Rembrandt Paintings*, Phaidon & Praeger

O. Benesch, *The Drawings of Rembrandt*, 6 vols, Phaidon

J. Bolten and H. Bolten-Rempt, *The Hidden Rembrandt*

Sir Kennth Clark, *Rembrandt and the Italian Renaissance*, John Murray

Henri Focillon and L. Goldscheider (Eds), *Rembrandt: Paintings, Drawings and Etchings*, Phaidon

Ludwig Munz, *Rembrandt*, Library of Great Painters

Christopher White, *Rembrandt as an Etcher: A Study of the Artist at Work*, Zwemmer

Christopher White and K. Boon, *Rembrandt's Etchings*, Zwemmer

Christopher Wright, *Rembrandt and his Art*, Masters Series, Hamlyn

M. Kitson, *Rembrandt*, Phaidon & Praeger

K. Roberts, *Rembrandt, Master Drawings*, Phaidon